Harry Potter™

FILM VAULT

VOLUME 3

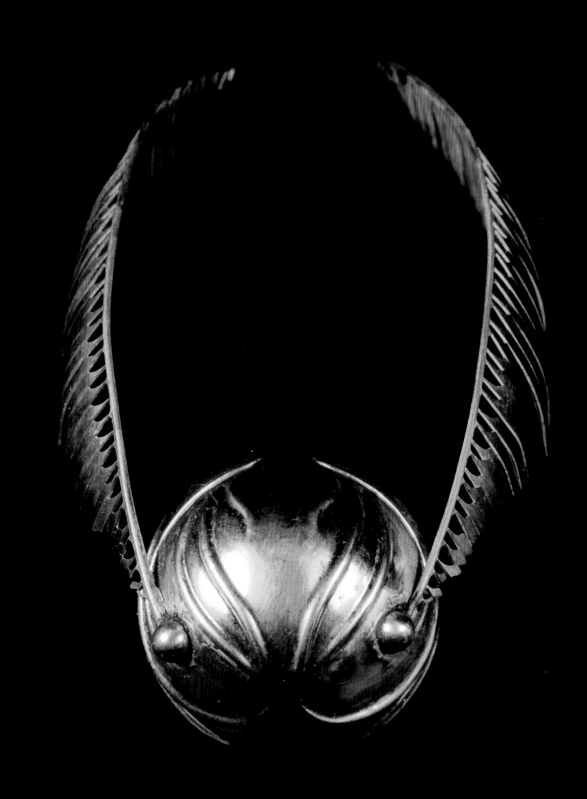

FILM VAULT

Volume 3

Horcruxes and the Deathly Hallows

By Jody Revenson

WIZARDING WORLD

INSIGHT EDITIONS

San Rafael, California

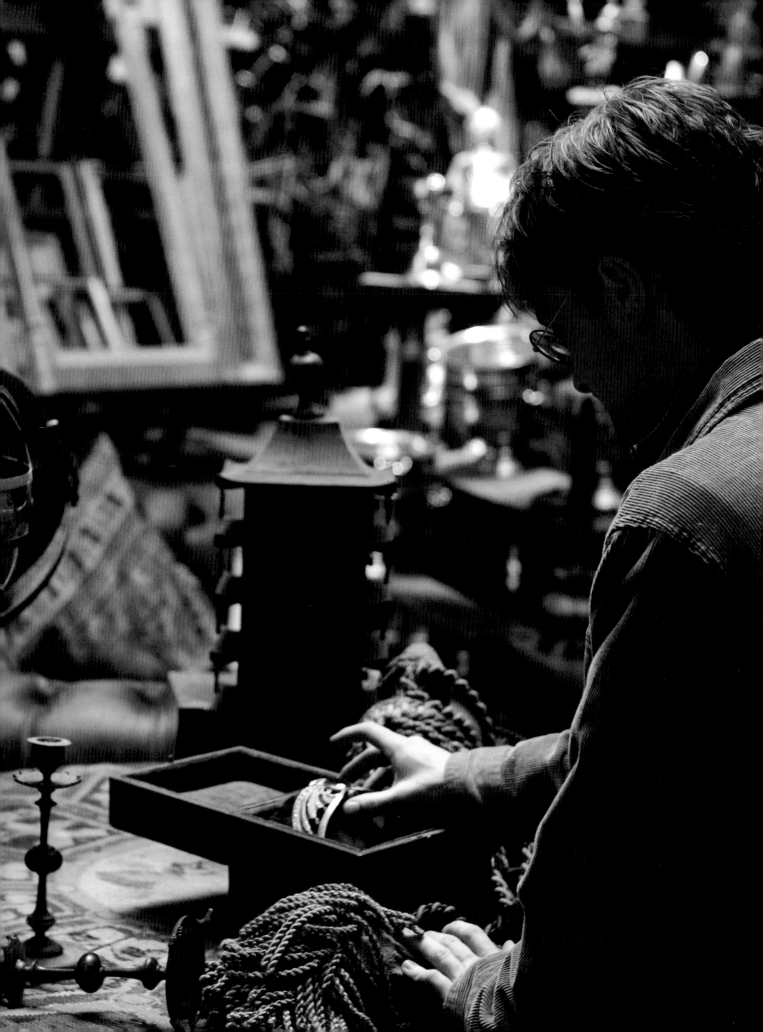

INTRODUCTION

When Harry Potter discovers he's a wizard, he also learns that he was attacked when he was an infant by the most powerful Dark wizard of all time. Lord Voldemort killed Harry's parents, but his next Killing Curse deflected off Harry, leaving only a lightning bolt scar on his forehead. It rebounded onto the Dark Lord himself, who lost his powers and his body but did not die—for he had spent his lifetime searching for immortality. In order for Harry to defeat Voldemort, he had to stop the Dark wizard from achieving that desire.

In his first screen story, *Harry Potter and the Sorcerer's Stone*, Harry needs to keep Voldemort from finding the titular Stone, which produces the Elixir of Life. Drinking it will give the Dark Lord back his physical body and ensure an eternal existence. Then in *Harry Potter and the Half-Blood Prince*, Harry finds out that Voldemort has created Horcruxes, a very Dark magic that keeps him alive through concealing parts of his soul in both animate and inanimate objects. Harry must find and destroy seven Horcruxes before Voldemort can be vanquished. In *Harry Potter and the Deathly Hallows – Part 1* and *Part 2*, it's revealed that there are three other objects—the Deathly Hallows—that when owned together can make one the Master of Death.

All of these objects seen on-screen are called "hero props," because they are handled by our heroes (and, yes, our villains) and are important to either the character or the story. Concepts for the hero props were envisioned by visual development artists, graphic artists, props designers, or technical draughts people and overseen by production designer Stuart Craig. Unusual to this film production, there was a dedicated props art director for each film, who coordinated the design and fabrication of the artifacts. Lucinda Thomson, Alexandra Walker, and Hattie Storey each held this position through the eight films, working with sculptors, painters, modelers, and other craftspeople.

The Horcruxes are a variety of objects, including a golden cup, a snake, a diary, and several pieces of jewelry. "A prop goes through a whole design process," says props supervisor Pierre Bohanna. "At least half a dozen designs would go in front of the director and

OPPOSITE: Harry Potter (Daniel Radcliffe) uncovers the Ravenclaw diadem in the Room of Requirement; ABOVE: Draft work for the sign at Platform 9¾; BELOW: Harry Potter's bedside table in the Gryffindor dorm during the events of *Harry Potter and the Half-Blood Prince* includes some of the most iconic artifacts in the story: his wand and glasses, the Marauder's Map, and his copy of *Advanced Potion-Making*.

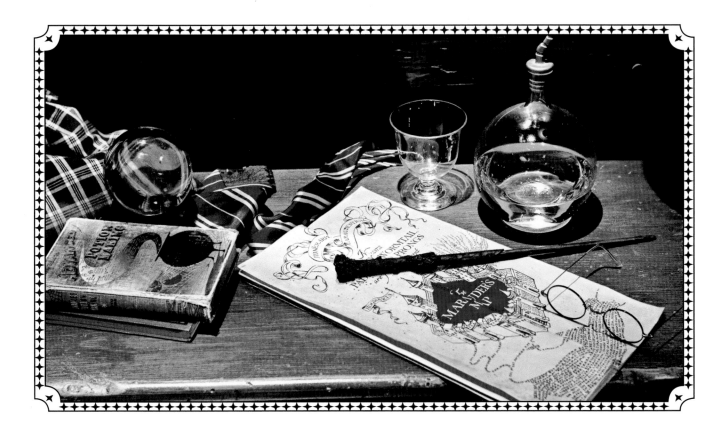

producers." Research was key to developing the props, but even with continuous reviews, changes were requested at many stages. "We made the Hufflepuff cup twice the size originally," he explains, "and they came back and said make it smaller." And it wasn't until the final cup was approved that designer Miraphora Mina found out that *thousands* of them needed to be manufactured.

Not all of the books had been written when the earliest films were being shot, so the props makers and graphic artists often didn't have all the necessary information during their design period. While creating the Horcrux ring that Dumbledore destroys in *Harry Potter and the Half-Blood Prince*, the art department was unaware that the ring's stone was actually the Resurrection Stone, one of the Deathly Hallows seen in *Harry Potter and the Deathly Hallows—Part 1* and *Part 2*. "Luckily, the seventh book came out before we had to finish designing that prop," says art director Hattie Storey, "because we hadn't known that it needed the symbol for the Deathly Hallows etched on it—and that symbol was still in development," she recalls. Fortunately, there was enough time to finalize the stone as described before the shooting of those scenes began.

"For us," Miraphora Mina sums up, "for every single design job we were given on the films, we would try to enter the character or the history behind that object. It was our duty to help tell the story in that one moment with that one piece." Designer Eduardo Lima adds, "You always have to think of the storytelling. You need to tell that story with that prop." The following pages detail how the artists and craftspeople behind the Harry Potter films sought to tell Harry's story through the design of many important props, from the Sorcerer's Stone to Lord Voldemort's Horcruxes, the Deathly Hallows, and other magical artifacts such as the Sword of Gryffindor.

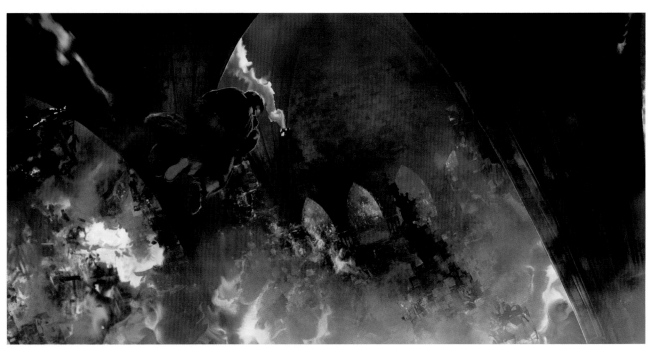

TOP: Marvolo Gaunt's ring sits on Professor Dumbledore's desk; ABOVE: The Room of Requirement is engulfed in Fiendfyre in concept art by Andrew Williamson for *Harry Potter and the Deathly Hallows — Part 2*; OPPOSITE: The necklace that cursed Katie Bell in *Harry Potter and the Half-Blood Prince*, designed by Miraphora Mina.

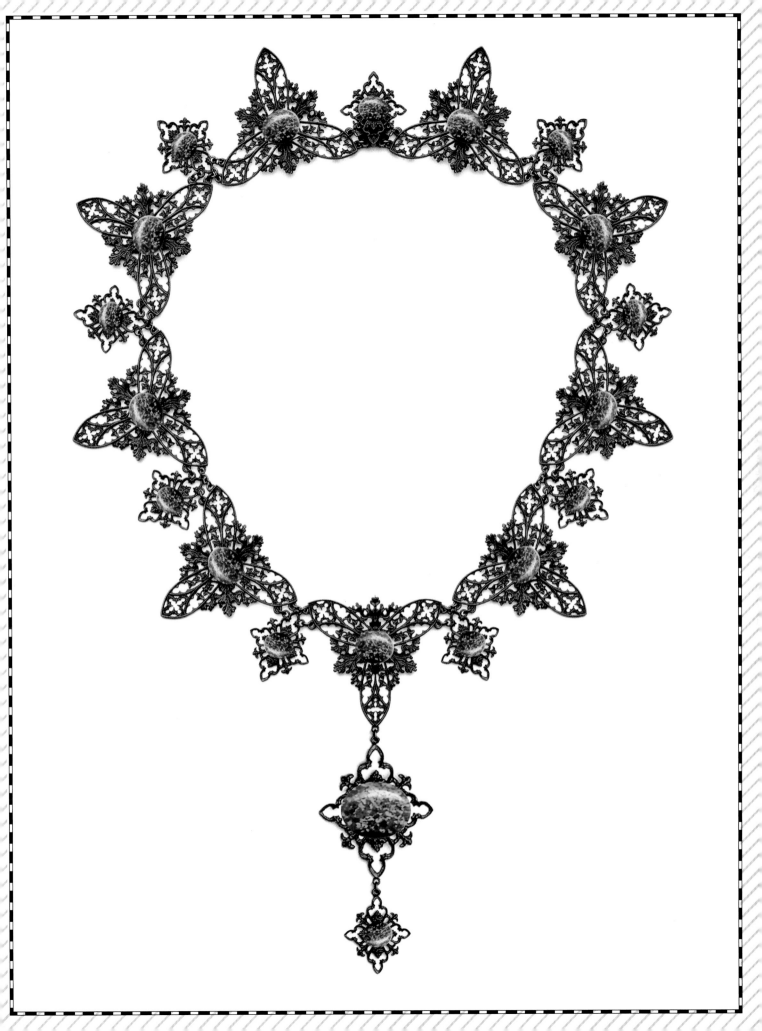

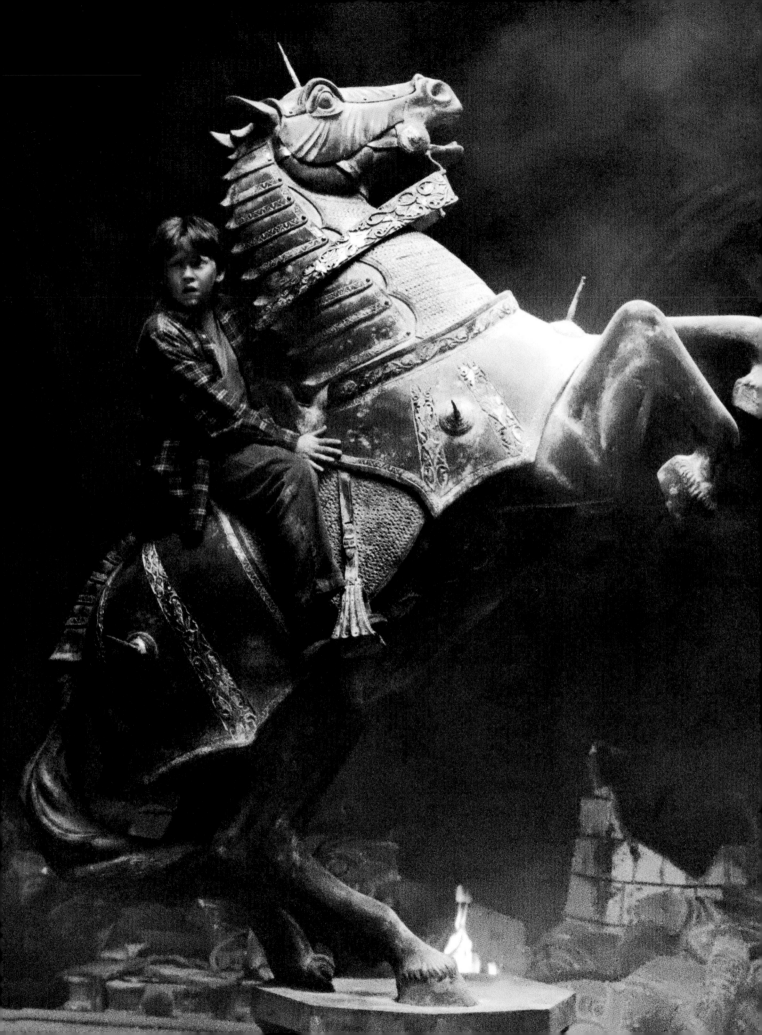

CHAPTER 1

THE SORCERER'S STONE

*"Of course! There are
other things defending the
Stone, aren't there? Spells
...enchantments."*

—Hermione Granger, *Harry Potter
and the Sorcerer's Stone*

SEARCHING FOR THE SORCERER'S STONE

As the book and movie title suggest, the story of *Harry Potter and the Sorcerer's Stone* is the pursuit by Harry Potter, Ron Weasley, and Hermione Granger of a magical object that is, as Hermione describes, "a legendary substance with astonishing powers. It will turn any metal into pure gold and produces the Elixir of Life, which will make the drinker immortal." In order to prevent Voldemort from acquiring the stone, the staff of Hogwarts have hidden it and created four security obstacles: the three-headed dog, Fluffy; a temperamental plant; a door that can only be opened by a winged key; and a life-size game of chess that must be won. Voldemort, who is still noncorporeal and so shares Professor Quirinus Quirrell's body, has passed them all. These tests will call upon each hero to contribute a skill that delineates their character: Hermione for her knowledge of spells, Harry for his broomstick-flying talents, and Ron for his proficiency at Wizard's Chess.

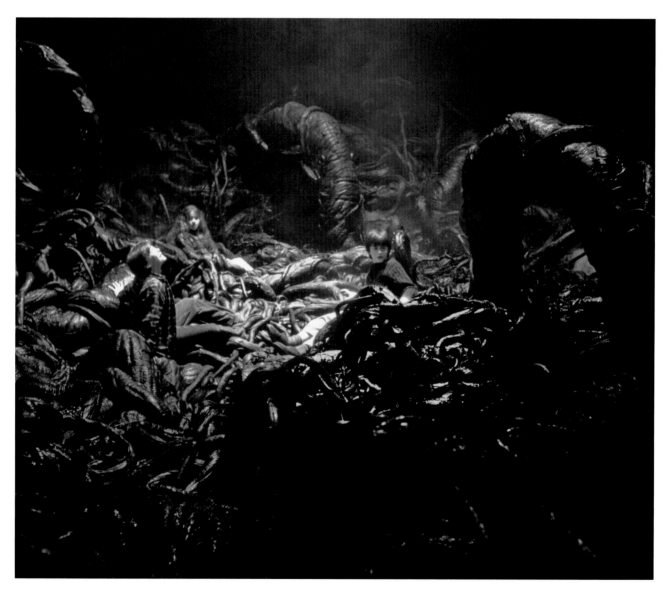

PAGE 8: Ron Weasley directs the life-sized Wizard Chess game from atop his knight's horse. Ron sacrifices his piece so that Harry Potter can win and retrieve the Sorcerer's Stone in the first Harry Potter film; ABOVE: A film still of Ron, Hermione, and Harry after landing in Devil's Snare; OPPOSITE: Visual development artwork by Cyrille Nomberg illustrates the arrival of Harry, Hermione, and Ron into the room of their chess game challenge.

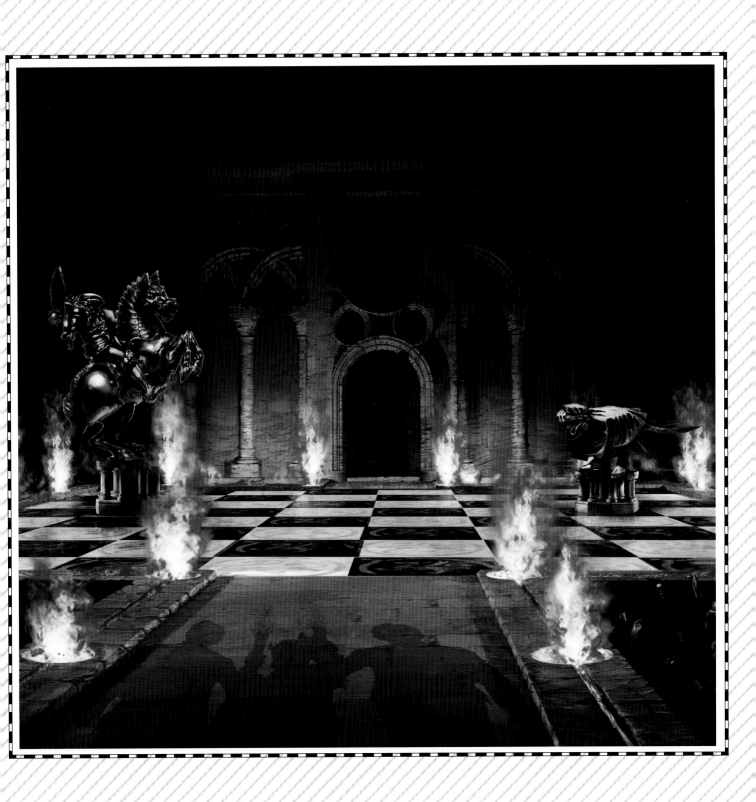

FLUFFY

"Well, of course he was interested in Fluffy!
How often do yeh come across a three-
headed dog, even if yeh're in the trade?"

—Rubeus Hagrid, *Harry Potter and the Sorcerer's Stone*

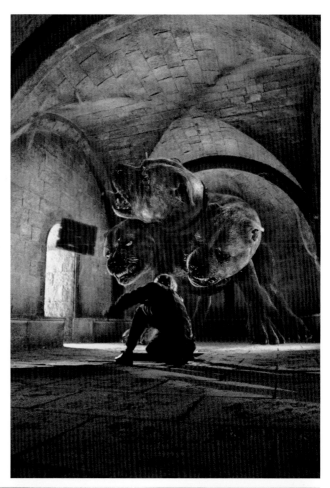

To protect the Sorcerer's Stone in *Harry Potter and the Sorcerer's Stone*, several professors set up obstacles to thwart a potential theft. The first of these obstacles is Fluffy, a three-headed guard dog provided by Rubeus Hagrid.

An important challenge to the creature designers was always to make the unbelievable believable. So a three-headed dog in *Harry Potter and the Sorcerer's Stone* needed to feel as if it was three individual dogs united in the same body. In order to accomplish this, the digital animators assigned a different personality to each of the heads: One was sleepy, one was smart, and one was very alert. This also provided an opportunity for comic interaction. Special attention was paid to having the heads act independently of each other, so their movements were never made in sync.

When Harry Potter, Ron Weasley, and Hermione Granger attempt to get past the sleeping dog, they need to move one of its giant paws off the trap door, so a full-scale, weighted version of Fluffy's right paw was created for the actors to move. All of Fluffy's remaining actions were computer generated, except for one. The drool that lands on Ron's shoulder? An unpleasant practical effect.

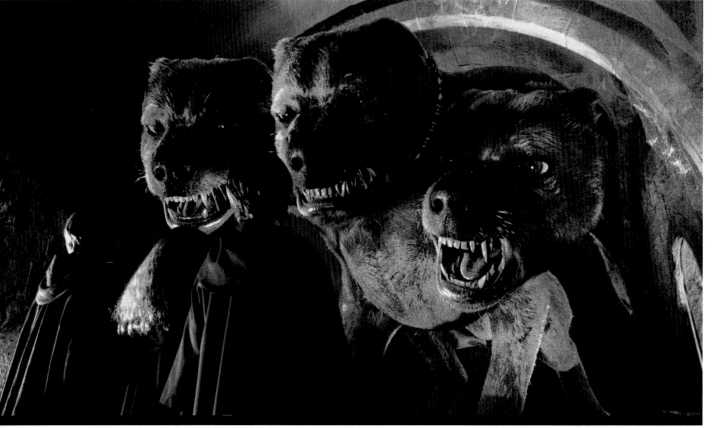

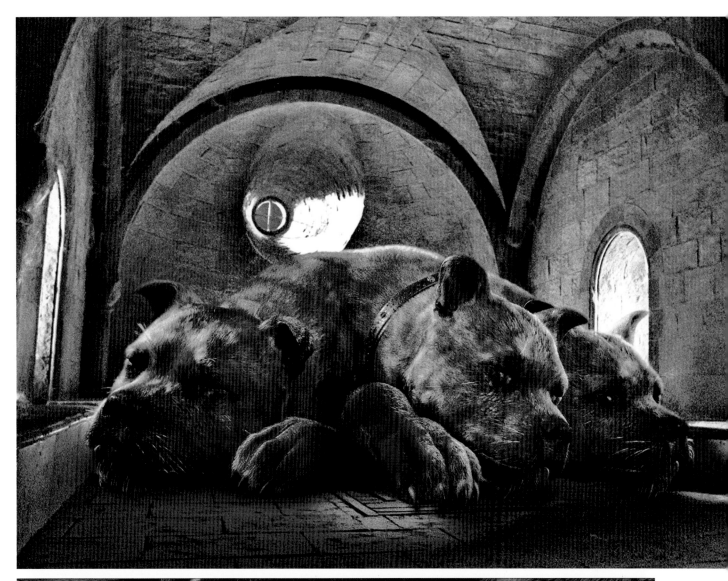

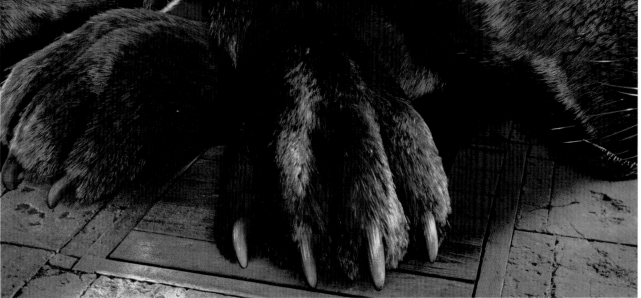

OPPOSITE BOTTOM: Ron Weasley (Rupert Grint), Hermione Granger (Emma Watson), and Harry Potter (Daniel Radcliffe) encounter the three-headed guard dog, Fluffy, in a scene from *Harry Potter and the Sorcerer's Stone*; OPPOSITE TOP AND THIS PAGE: Screen stills of Fluffy include his two huge paws and his three huge heads.

DEVIL'S SNARE

"Devil's Snare, Devil's Snare, it's deadly fun, but will sulk in the sun!"

—Hermione Granger, *Harry Potter and the Sorcerer's Stone*

Devil's Snare is a fleshy, rubbery plant with long shoots and creepers that prefers dark, dank environments. The plant is used as the second obstacle that Harry Potter, Ron Weasley, and Hermione Granger need to overcome in *Harry Potter and the Sorcerer's Stone* on their way to find the titular object. Devil's Snare kills its victims by wrapping itself around anything or anyone that treads or falls upon it. While trapped in the plant in *Sorcerer's Stone*, Hermione recalls that you can be released by Devil's Snare only by letting your limbs go limp or shining a bright light on it, preferably sunlight.

The filmmakers assumed that the Devil's Snare sequence in *Harry Potter and the Sorcerer's Stone* would be created digitally, but then discovered that the production cost would be prohibitive.

Presented with this challenge, the filmmakers realized they could employ a practical effect inspired by early cinema. The scene of the Devil's Snare vines encircling the three actors was actually shot in reverse. The giant vines were wrapped around the actors first. Hidden underneath the mass of vegetation were puppeteers who slowly pulled the tentacles off and away as the actors "struggled." By playing the film backward, it would appear as if the actors were being enveloped by the plant. The only visual effect was the *Lumos Solem* Spell from the wand.

ABOVE: Tendrils of Devil's Snare envisioned by Paul Catling for *Harry Potter and the Sorcerer's Stone*; OPPOSITE TOP: Harry Potter is encircled by Devil's Snare in concept art by Paul Catling; OPPOSITE BOTTOM: Harry (Daniel Radcliffe) struggles with the Devil's Snare obstacle in the same scene from *Sorcerer's Stone*.

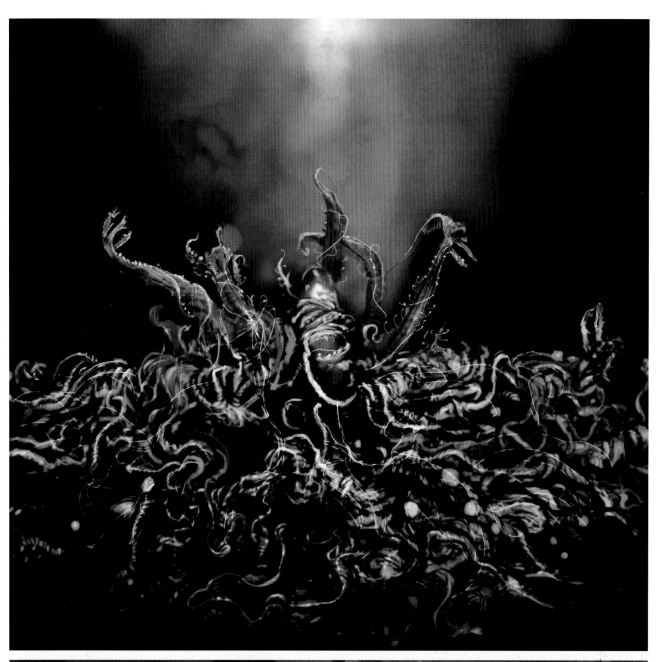

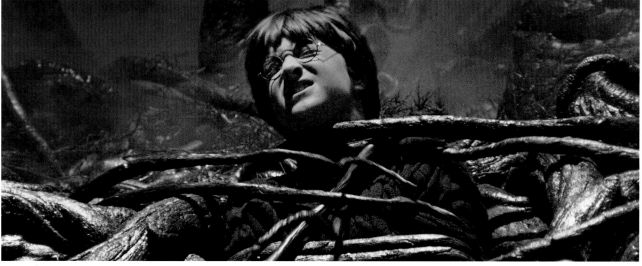

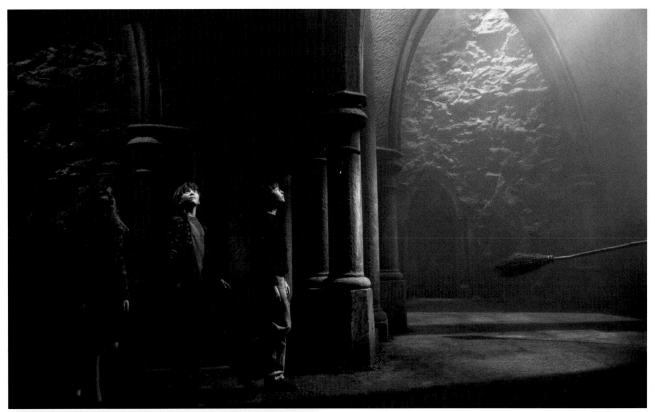

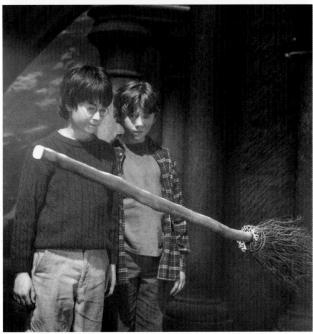

TOP: When Harry, Ron, and Hermione first enter the room containing the winged keys, Hermione first mistakes them for birds; ABOVE: Harry and Ron examine the levitating broom left in the room; ABOVE RIGHT: The winged key prop used to open the locked door; OPPOSITE TOP: Concept art for the winged keys by Gert Stevens; OPPOSITE BOTTOM: Harry Potter flies among a swarm of winged keys.

WINGED KEYS

"Curious. I've never seen birds like these."
"They're not birds, they're keys."

—Hermione Granger and Harry Potter, *Harry Potter and the Sorcerer's Stone*

After sidestepping Fluffy and dropping through Devil's Snare, the next challenge to get closer to the Sorcerer's Stone is to get through a locked door. After Hermione tries the charm *Alohamora*, which, to her frustration, does not work, Ron and Harry realize that they must find and catch the right key in a swarm of winged keys flying through the room. While the design of the keys was relatively simple, they "had to be scary and wild, but not *too* scary or *too* wild," explains visual effects supervisor Robert Legato. "The more beautiful you make something, the more nonthreatening it becomes." Legato knew it was a fine line between the keys being frightening and being intimidating. Another consideration was their movement: "They are in essence tied together, the way they move, which affects the way they'll look and the way they're lit on-screen," he says. After the final design was tested and approved in a digital animatic, the many keys were made to move in concert like a flock of birds. The wings of the key that opens the door were crafted in an iridescent shot silk.

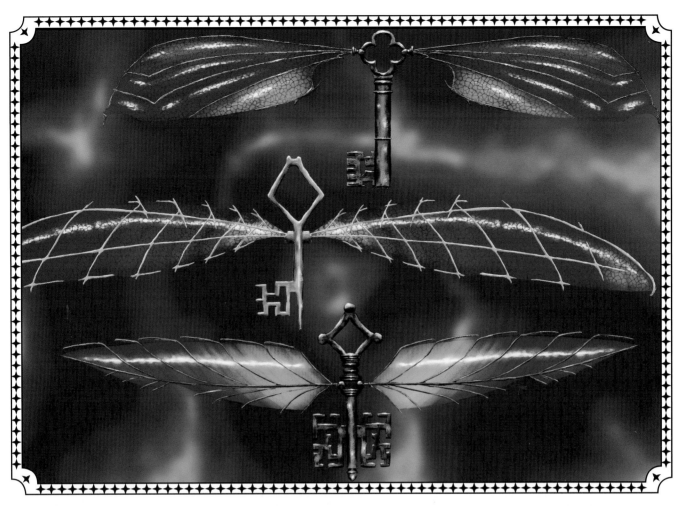

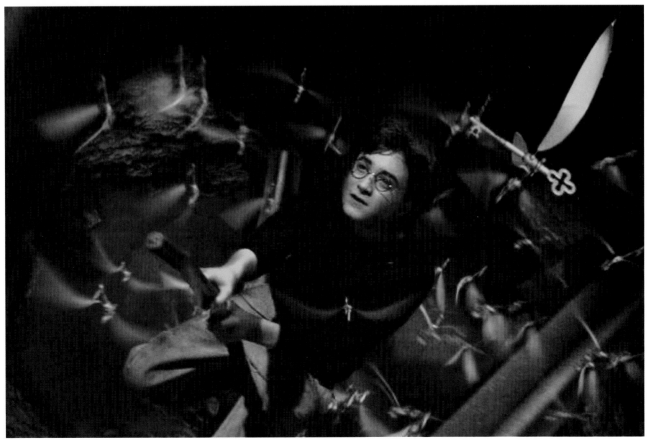

CHESS PIECES

"It's obvious, isn't it? We've got to play our way across the room. All right. Harry, you take the empty bishop's square. Hermione, you'll be the queenside castle. As for me, I'll be a knight."

—Ron Weasley, *Harry Potter and the Sorcerer's Stone*

The final challenge before Harry Potter's confrontation with Voldemort is to win a game of Wizard's Chess. Director Chris Columbus's preference was always to see if the action could be created practically instead of digitally, and the special effects and props departments were glad to comply. Full-size models of the thirty-two chess pieces, some of them twelve feet high and weighing up to five hundred pounds, were sculpted in clay and cast in various materials according to their use. The prop makers produced the swords, maces, armor, and even the bishop's staffs that were their armaments. "Then we had to make the chess pieces move," says special effects supervisor John Richardson, "which was a challenge because of their size and weight, and the fact that their bases were very small." Richardson and his team rigged the pieces that needed to move with radio controls. "We could drive a horse forward and then stop, and then move it sideways and stop very cleanly."

"While the pieces on the set were fully built and could shift across the board," says visual effects producer Emma Norton, "they weren't articulated. So when you see one of those pieces do more than just move forward, they're computer-generated versions. But when we create something in CG, we will borrow as much as we can from the model, which has been painted to be photographed

BELOW AND TOP RIGHT: Visual development art of the black side's pawn and queenside castle chess pieces by Cyrille Nomberg and Ravi Bansal; RIGHT: Finishing touches are added to one of the chess set's kings; OPPOSITE: A close-up reference photo of the white side's chess pieces features the rook, knight, bishop, and pawns, some of which moved via radio controls.

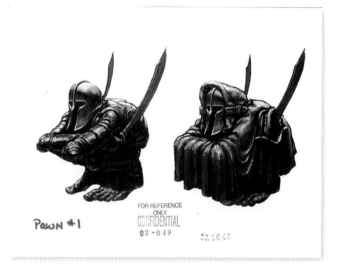

FOR REFERENCE ONLY
CONFIDENTIAL
02-049
PAWN #1
XX1040

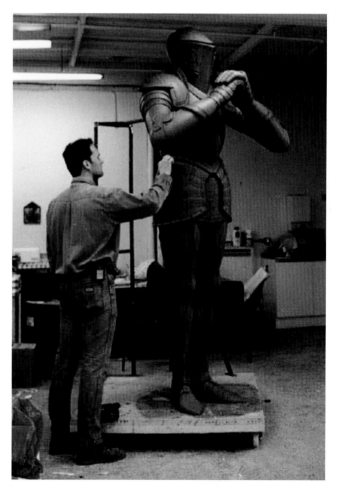

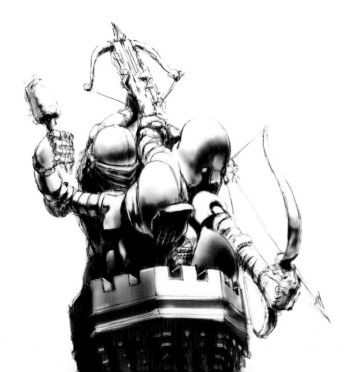

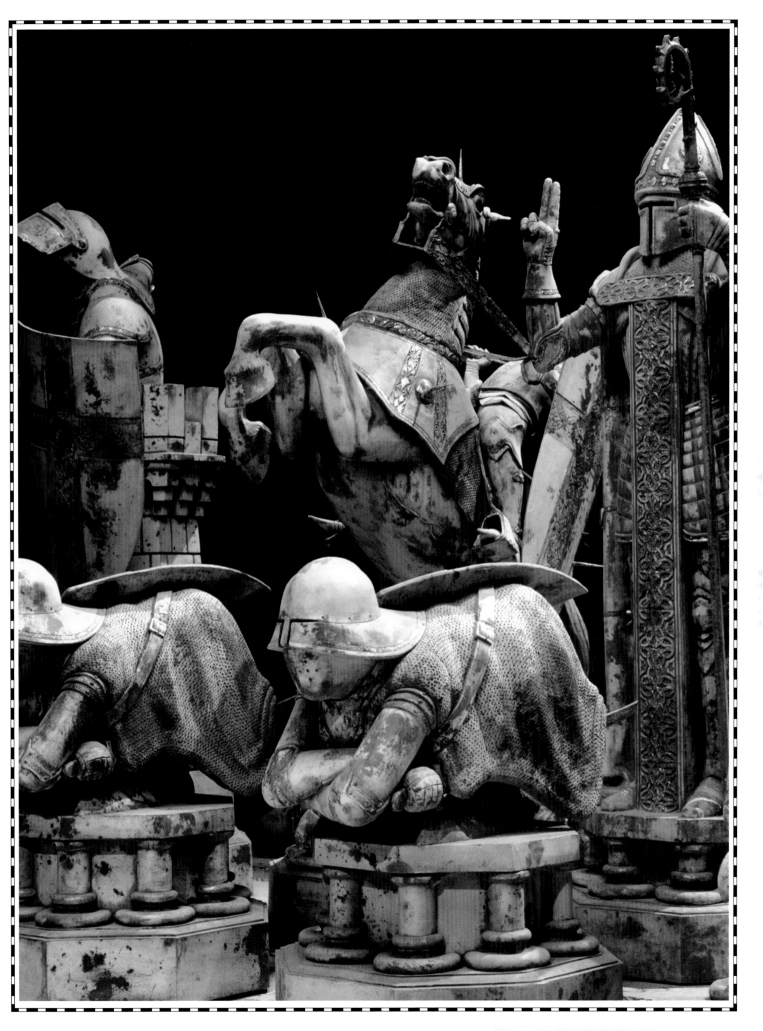

on-screen. So we photograph it, cyberscan it, take textures from the prop and from whatever the art department has provided and treat it like skin, the texture skin. Then we build a CG model and wrap that texture around it. So for all intents and purposes, you're looking at the real thing."

The most important consideration of the scene was that when a piece was taken by the opposite side, it would explode, meaning the young actors would be involved in a scene with blasts and bursts and flying rubble. Instead of pyrotechnics, Richardson and his team used compressed air devices activated via remotes to blow the pieces up in a very controlled way. "There was some flame on the set, and smoke, so we had air and fire and bangs and pretty much a little bit of everything else we come across in effects," Richardson explains. The "broken" pieces seen after the explosions were individually sculpted and cast, and not just smashed originals. Digital dust and debris were added after the scene was shot. The "marble" of the chessboard's squares was created using a well-known art technique of squirting oil paint into a vat of water—in this case, a six-foot-square tank—and then placing paper on top to absorb the swirling colors. The best versions were scanned, enhanced digitally, and then laid down on the set. "That was an incredible set," actor Rupert Grint (Ron Weasley) recalls. "And such a cool scene, with pieces being smashed and exploding around us. I've still a broken piece of the horse I was riding!"

TOP, RIGHT, AND OPPOSITE TOP: Concept art by Cyrille Nomberg and Ravi Bansal of the Wizard Chess pieces, experimenting with different weaponry, postures, and girths; ABOVE RIGHT: Harry Potter approaches the twelve-foot-high white queen in a reference photograph taken on the set of *Harry Potter and the Sorcerer's Stone*; OPPOSITE BOTTOM Behind each side of the chess board were pits where the exploded and taken pieces were piled up.

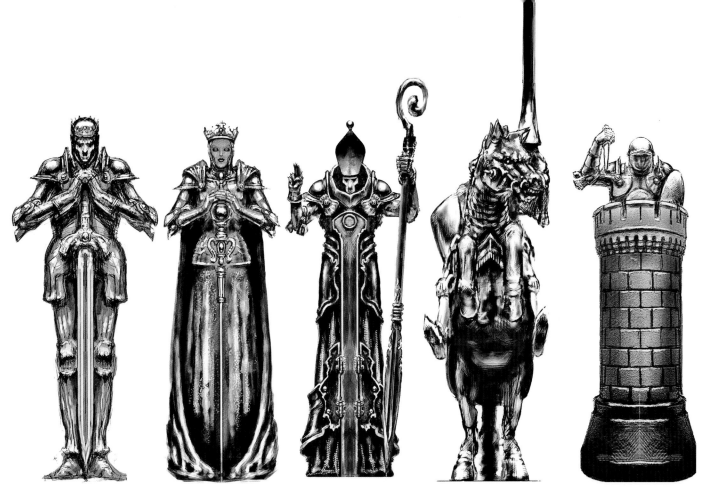

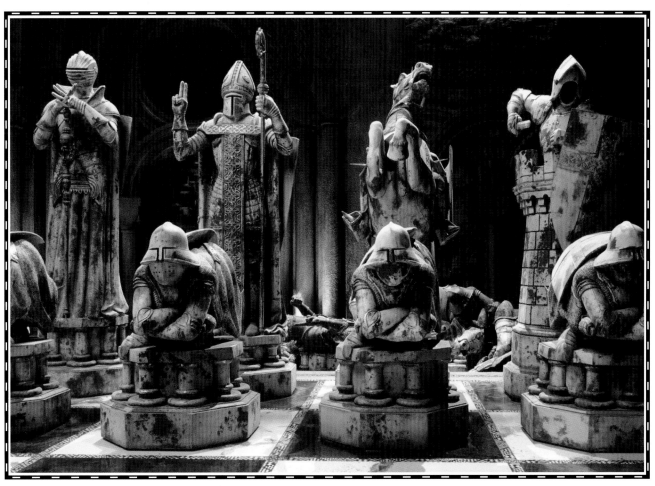

THE MIRROR OF ERISED

"It shows us nothing more or less than the deepest, most desperate desires of our hearts."

—Albus Dumbledore, *Harry Potter and the Sorcerer's Stone*

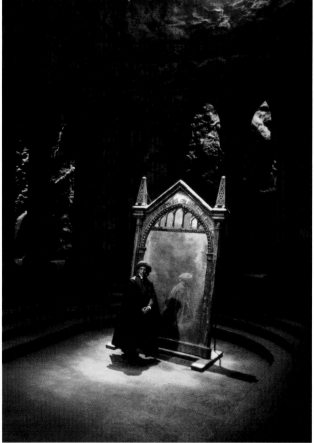

When Harry stays at Hogwarts over the Christmas holiday in his first year, he's given an assignment by Hermione to find out more information about Nicolas Flamel, the owner of the Sorcerer's Stone. Using his Invisibility Cloak, Harry sneaks into the Restricted Section of the Library and looks through the shelves, but when one of the books screams at him, he drops the lantern he's been carrying and runs. Argus Filch, the caretaker, hears this and runs after him, trying to find out what's going on.

To hide, Harry enters what looks like a classroom that is not in use. The design of the room, with its fluted columns and ribbed vault ceiling, bears a resemblance to the Cloisters and entrance to Bute Hall at the University of Glasgow in Scotland. Though the university was founded in 1451, Bute Hall and its Cloisters were built in the 1870s in the Gothic revival style.

The only piece in the shadowy room is a gigantic standing mirror, called the Mirror of Erised. Harry is entranced by the mirror, which shows one's deepest desire; as he looks into it, he suddenly sees his parents reflected behind him. When Dumbledore finds him sitting in front of the mirror a bit too often, he tells him not to dwell in dreams, but to live. The mirror, which Dumbledore moves to another location, later plays an important role in Harry's defeat of the combined Professor Quirrell–Lord Voldemort, who is trying to get the Sorcerer's Stone. Harry sees it in his own possession, in his pants pocket, when he looks into the mirror.

The mirror is a mash-up of different architectural styles: The outer sides are Corinthian columns, which bracket an inner set of smaller Doric columns embellished with a knot pattern. The principal style is Gothic; seven graduated lancet-style arches are framed by a larger one. Above this is a triangular arch adorned with palmettes, which supports the final toppers—three obelisks. The inscription above the biggest arch of the mirror reads: *Erised stra ehru oyt ube cafru oyt on wohsi*. It's not a magical language, but rather the mirror image of the sentence "I show not your face but your heart's desire," with the letters arranged in unique combinations. Unlike most props, which were duplicated for different uses and in case of breakage during filming, only one Mirror of Erised was ever created.

TOP LEFT: Set photography captures the moment Harry reaches out to the mirror, having seen his parents reflected behind him; BOTTOM LEFT: Professor Quirrell (Ian Hart) sees his reflection in the Mirror of Erised; OPPOSITE: A props reference shot of the Mirror of Erised with three (rather than two) obelisks.

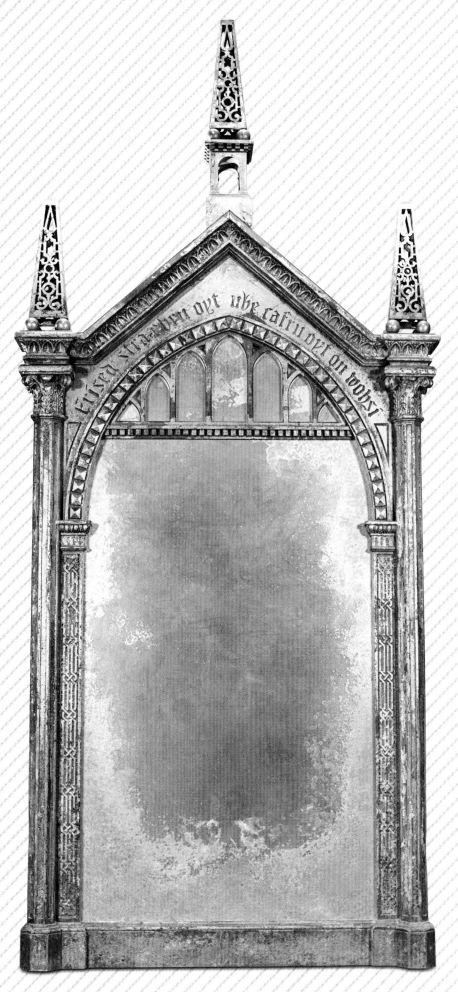

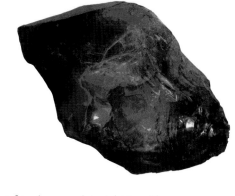

THE SORCERER'S STONE

"I see myself holding the stone. But how do I get it?"

—Quirinus Quirrell, *Harry Potter and the Sorcerer's Stone*

What prop could be more important in the first film than the titular Sorcerer's Stone? When the design department asked J.K. Rowling what the stone should look like, she described it as an uncut ruby. Props supervisor Pierre Bohanna began with the idea of it having a pebble-like shape, but on film, those stones appeared too flat. They tried fabricated stones available on the open market. They weren't much more satisfying. "Although they worked and people were happy with them," says Bohanna, "it was very difficult for [them] to seem anything other than a flat pebble unless you were really close to [them]."

"Then Stuart [Craig] took a complete right turn," he remembers. "He had a collection of different quartz stones and said, maybe we're being too clever and complicated about this." Choosing one of the crystals, he asked Bohanna to replicate it in red. "And that's exactly what we did."

Several of these prop stones were created out of plastic, which has the tendency to look more like a big piece of candy than a ruby. So in order to give it the shimmering, flickering appearance of a real gem, filmmakers turned to the basics from Lighting 101. The stone reflected the light of a small flame placed on top of the camera during filming.

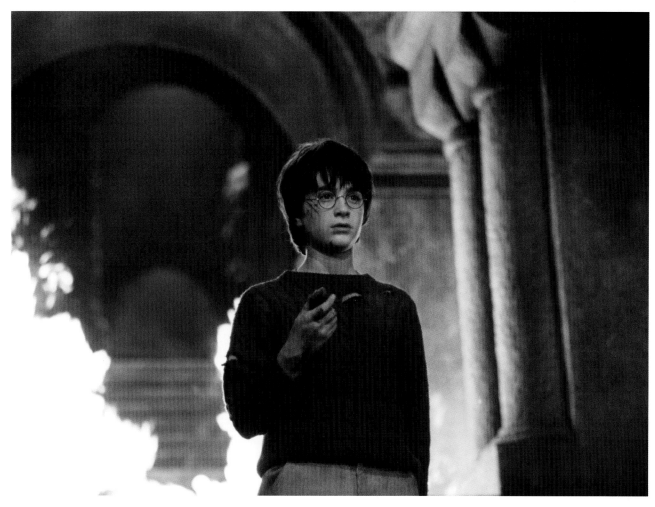

TOP RIGHT: A close-up of the Sorcerer's Stone; ABOVE AND OPPOSITE: In a movie still from *Harry Potter and the Sorcerer's Stone*, Harry holds the Sorcerer's Stone, which shows up, to his surprise, in his pants pocket.

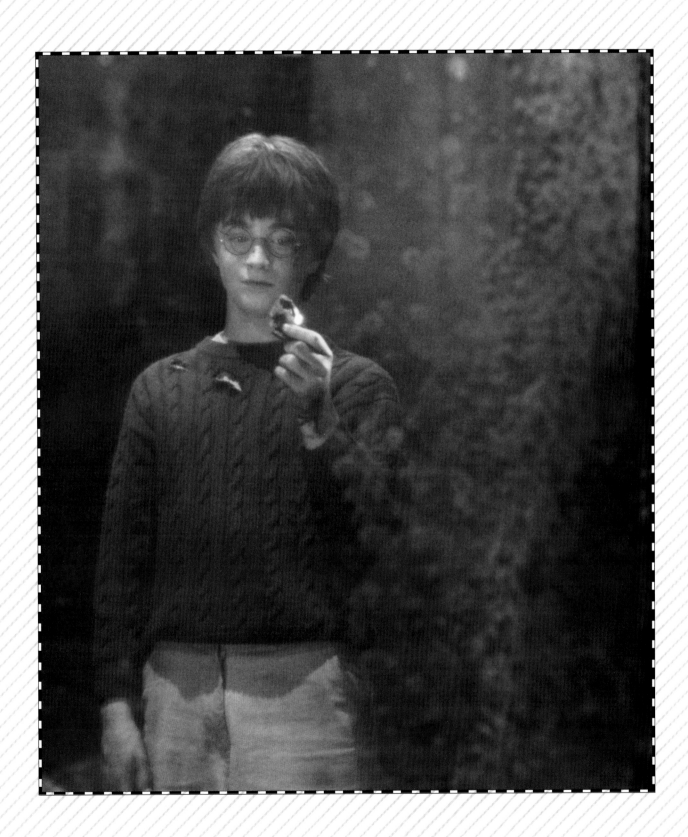

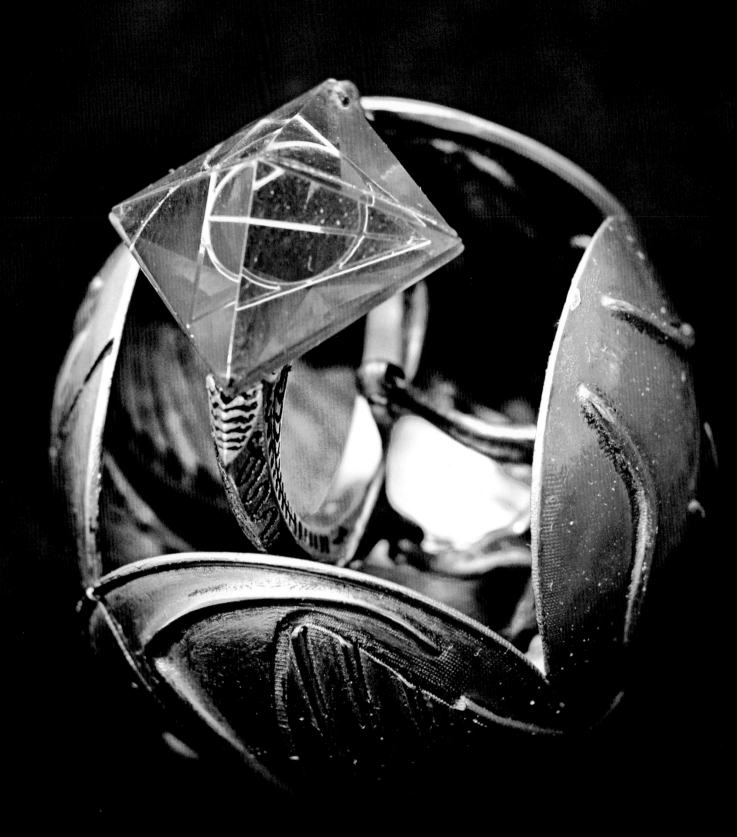

CHAPTER 2

HORCRUXES AND HALLOWS

"But magic ... especially Dark Magic ... leaves traces."

—Albus Dumbledore, *Harry Potter and the Half-Blood Prince*

LORD VOLDEMORT'S HORCRUXES

"But if you could find them all... If you did destroy each Horcrux..." "One destroys Voldemort."

—Harry Potter and Albus Dumbledore, *Harry Potter and the Half-Blood Prince*

In an effort to gain immortality, the young Lord Voldemort, then called Tom Riddle, coerced his Potions master, Horace Slughorn, into explaining what a Horcrux was—a way to protect one's body by concealing a part of one's soul in an object or a living thing—and how to generate one. Lord Voldemort has created seven Horcruxes that Harry Potter must find, which, once destroyed, will allow him to vanquish Lord Voldemort. The plot rests on these articles, which are, in their simplest forms, a cup, a ring, a book, a snake, a tiara, a necklace, and a boy who lived. Their designs needed to be exceptional and memorable, as these are perhaps the most consequential artifacts in the Harry Potter films.

PAGE 26: Both a Horcrux and a Deathly Hallow, the Resurrection Stone in Marvolo Gaunt's ring emerges at the conclusion of *Harry Potter and the Deathly Hallows – Part 2* from the first Golden Snitch Harry Potter caught playing Quidditch; RIGHT: Harry Potter's notebook, showing notes important to his search for Horcuxes; BELOW: A props reference shot for *Harry Potter and the Half-Blood Prince* of the first two destroyed Horcruxes, Tom Riddle's diary and Marvolo Gaunt's ring, as they sit atop Albus Dumbledore's desk; OPPOSITE: Professor Slughorn explains how a Horcrux is created to a young Tom Riddle, *Harry Potter and the Half-Blood Prince*.

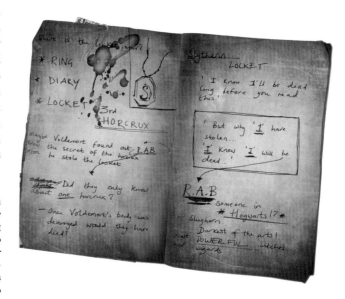

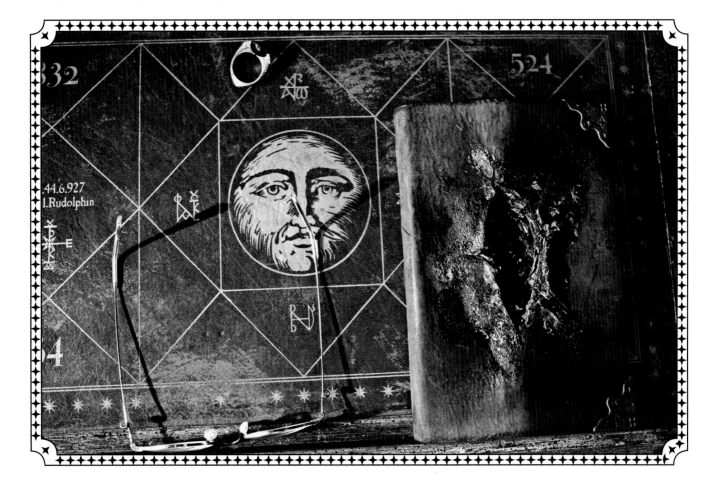

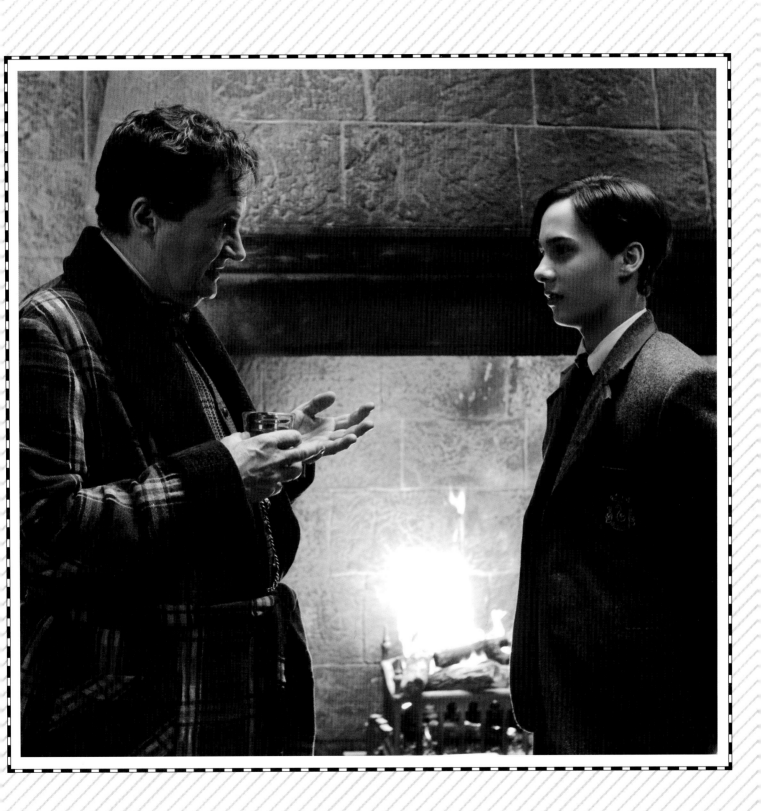

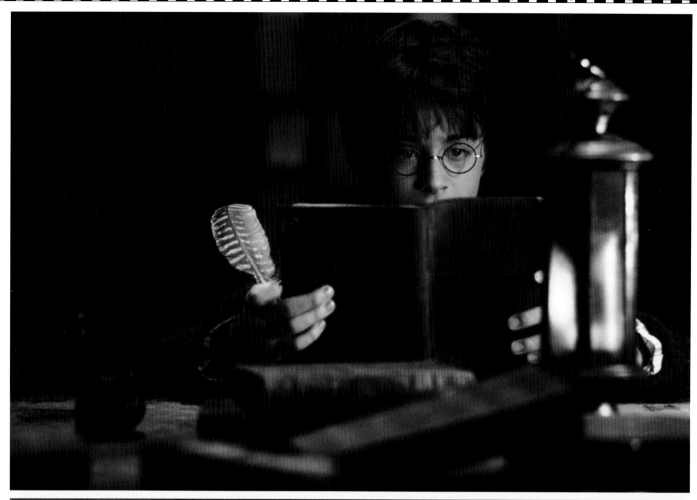

TOM RIDDLE'S DIARY

"I knew it wouldn't be safe to open the Chamber again while I was still at school. So I decided to leave behind a diary, preserving my sixteen-year-old self in its pages, so that one day I would be able to lead another to finish Salazar Slytherin's noble work."

—Tom Marvolo Riddle (Lord Voldemort), *Harry Potter and the Chamber of Secrets*

When creating a hero prop (or in this case, perhaps it should be called a "villain prop"), the prop makers needed to evaluate how its condition might change through the events of the movie story. Tom Riddle's diary starts in fairly good condition when Lucius Malfoy secretly adds it to Ginny Weasley's school supplies in *Harry Potter and the Chamber of Secrets*. Its black leather cover exhibits only a few scuffs and scratches that were created by a method called "breaking down," wherein the prop makers pound, stain, rip, or scrape up an object. Later in the film, the diary is damaged by water, and then destroyed by the venom from a Basilisk.

The last diary prop was outfitted with a tube that pumped out black fluid in a practical effect when Harry pierces it with the snake's fang. The fangs on the Basilisk that Harry encountered in the Chamber were constructed from different materials suited to their purpose. "Stunts and close-ups present different requirements," explains Pierre Bohanna. "The Basilisk fang used to destroy Tom Riddle's notebook is a rubberized one designed not to hurt if you accidentally stab yourself with it." The fangs inside the Basilisk's mouth were more solid where they were embedded, but still flexible and rubbery at the pointed end for safety. The fangs were also broken down to give them the appearance of years of wear and tear. Hermione Granger and Ron Weasley return to the Chamber in *Harry Potter and the Deathly Hallows – Part 2* to gather another fang, used to destroy both the cup and diadem Horcruxes.

OPPOSITE: Harry examines Tom Riddle's diary, *Harry Potter and the Chamber of Secrets*; BELOW: Prop reference shots for *Harry Potter and the Half-Blood Prince* of the first destroyed Horcrux, Tom Riddle's diary.

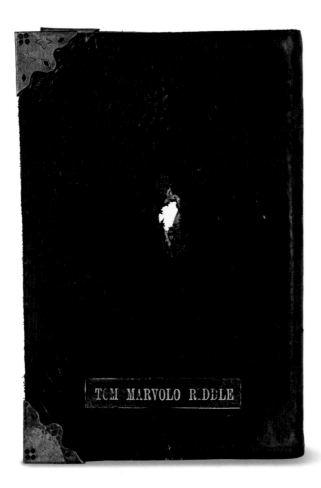

MARVOLO GAUNT'S RING

"They could be anything. The most commonplace of objects. A ring, for example ..."

—Albus Dumbledore, *Harry Potter and the Half-Blood Prince*

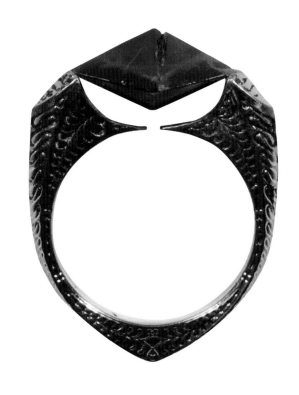

Dumbledore reveals to Harry how Lord Voldemort has taken objects familiar to him and turned them into Horcruxes in *Harry Potter and the Half-Blood Prince*. The Headmaster reminds him of the diary Harry destroyed and shows him another: a gold ring topped with a black stone. This ring, which belonged to Tom Riddle's grandfather, is seen in the Pensieve flashbacks as Tom persuades Professor Slughorn to reveal the method of making these Dark objects. While the ring is seen only fleetingly, it impacts the story greatly as Dumbledore explains that a Horcrux leaves a trace of Dark Magic upon it, which will enable Harry to find the remaining ones. The final look of the ring was created by Miraphora Mina, who designed and crafted many of the jewelry props in the film series. The ring's design showcases an obvious Slytherin connection, as two stylized snake heads meet to hold the gem in their jaws. Sadly, although Dumbledore succeeds in destroying this Horcrux with the Sword of Gryffindor, it eventually costs him his life.

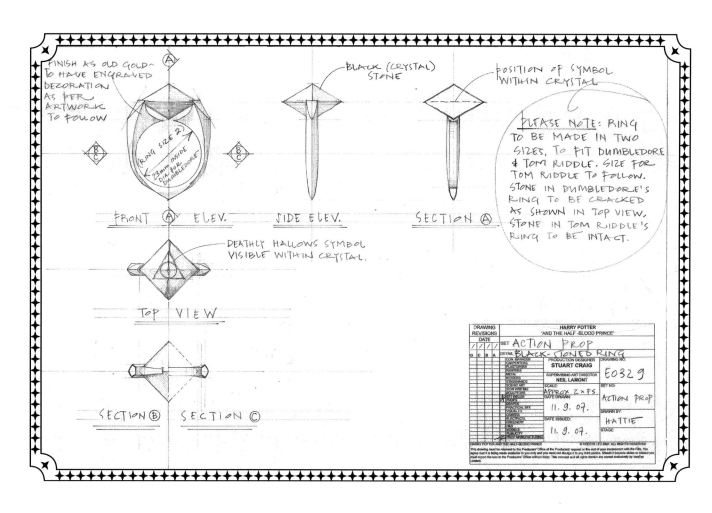

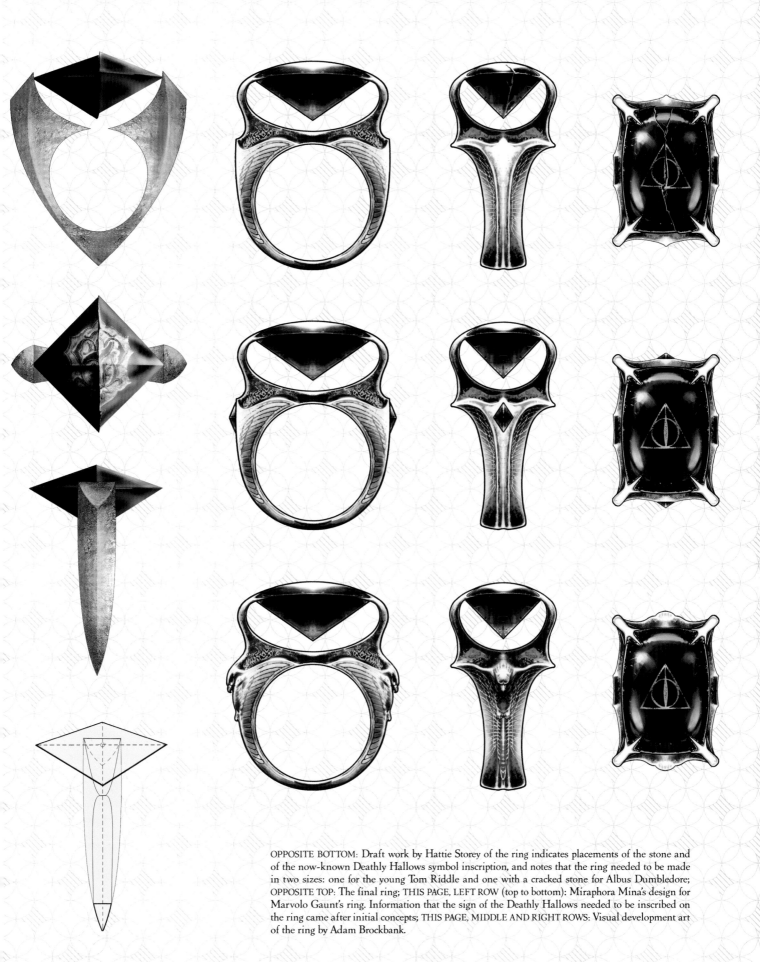

OPPOSITE BOTTOM: Draft work by Hattie Storey of the ring indicates placements of the stone and of the now-known Deathly Hallows symbol inscription, and notes that the ring needed to be made in two sizes: one for the young Tom Riddle and one with a cracked stone for Albus Dumbledore; OPPOSITE TOP: The final ring; THIS PAGE, LEFT ROW (top to bottom): Miraphora Mina's design for Marvolo Gaunt's ring. Information that the sign of the Deathly Hallows needed to be inscribed on the ring came after initial concepts; THIS PAGE, MIDDLE AND RIGHT ROWS: Visual development art of the ring by Adam Brockbank.

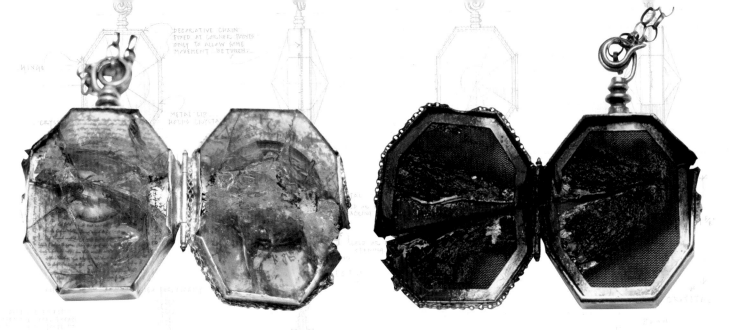

SALAZAR SLYTHERIN'S LOCKET

*"I know I will be dead long before you read this....
I have stolen the real Horcrux and intend to destroy it."*

—Harry Potter reading R.A.B.'s note, *Harry Potter and the Deathly Hallows – Part 1*

Unknown to Dumbledore and Harry when they seek the locket Horcrux in *Harry Potter and the Half-Blood Prince*, there are actually two lockets: one that had belonged to Salazar Slytherin and was passed down to Voldemort, which the Dark Lord turned into a Horcrux and secreted in a crystal cave, and a locket that Sirius Black's brother, Regulus, left as a replacement when he stole the real locket Horcrux. "This was a case of not knowing that the locket wasn't a real locket when we started designing it," says art director Hattie Storey. So two lockets, one refined and one less so, needed to be created. "The locket was a challenge," says Miraphora Mina, "because it was full of evil, but it also needed to have a beauty to it; to be something appealing and something historical."

The real Slytherin locket was based on an eighteenth-century piece of jewelry from Spain that Mina saw in a museum. She loved the idea that the crystal on the front was faceted, "so it was almost like, as there were lots of different sides, you didn't quite know which bit of it was going to open."

As described in the book, the locket was adorned with a jeweled "S" on the front created from diamond-cut green stones. Mina surrounded this with astrological symbols, specifically the aspect notations used for horoscopes that refer to the relative angles of planets to each other. There is also an inscription inside the ring and another, longer inscription on its faceted back.

"The locket was a treat to conjure up," Mina states. "I was allowed to play with every detail on that locket, so even the loop that goes onto the chain is a little snake wound around it. The great thing on Harry Potter was that all these things were manufactured on-site, so discussions could take place with the prop maker about the right materials to use, and that would perhaps necessitate an alteration of the design a little bit." When it came time for Ron Weasley to destroy the Horcrux with the Sword of Gryffindor in *Harry Potter and the Deathly Hallows – Part 1*, duplicates needed to be made. "The original brief was that we'd only need two or three," recalls Pierre Bohanna. "It ended up being forty."

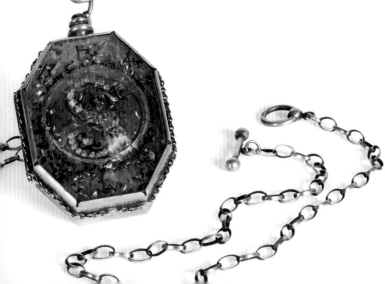

LEFT: The fake locket, a much cruder version of the real one, housed a tiny piece of parchment that Miraphora Mina inscribed in her facet as a graphic designer; TOP: Salazar Slytherin's locket after Ron Weasley destroys it with the Sword of Gryffindor in *Harry Potter and the Deathly Hallows – Part 1*; BACKGROUND (ABOVE): Draft work of the locket by Hattie Storey shows views of the artifact from every angle; OPPOSITE (top to bottom): Storyboard art showing the progression of the locket from its retrieval in the Horcrux cave to the discovery that it is not the real locket in *Harry Potter and the Half-Blood Prince* to art and still photography showing the real locket's destruction in *Harry Potter and the Deathly Hallows – Part 1*; OPPOSITE RIGHT: Concept art of different suggestions for the "S" design by Miraphora Mina.

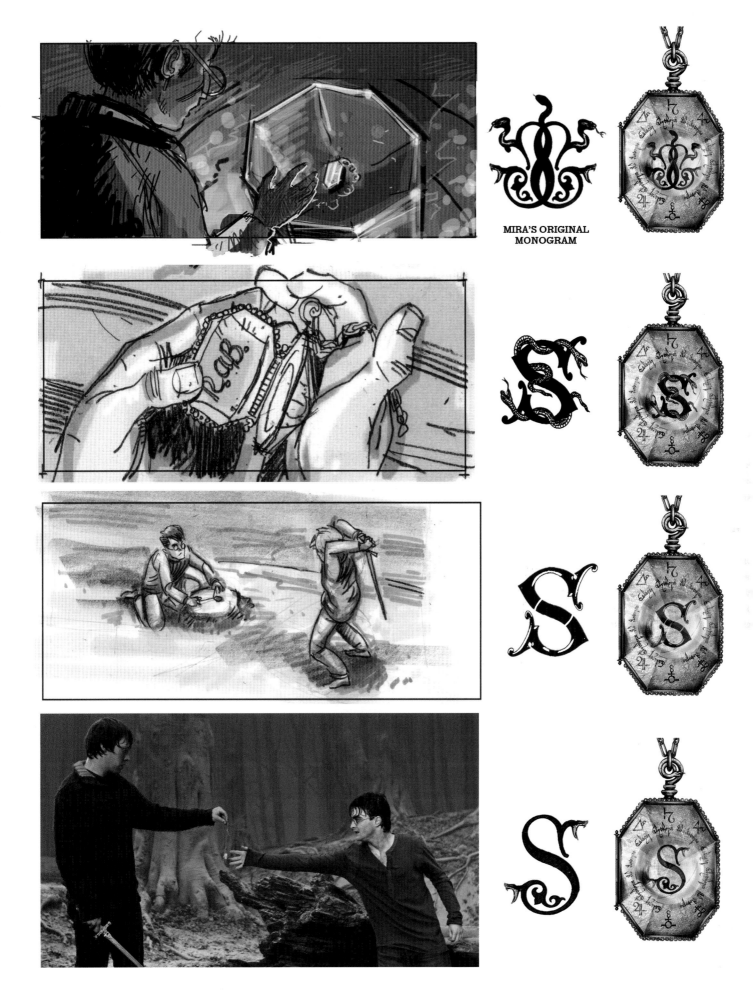

MIRA'S ORIGINAL
MONOGRAM

CUT

Harry's POV.
Dumbledore fills ladle and raises it....

TILT UP ...

Flare circles round out of shot
..see diagram

(45a)

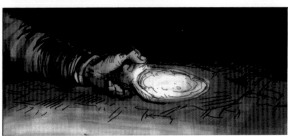

Cont'd

with ladle as it rises...

Cont'd over

(45b)

Cont'd

Harry's POV.

1. Dumbledore fills and raises third cup of liquid.

2. he nearly drops cup.

3. Grabs hold of the side of the basin.

Flare circles round out of shot
..see diagram

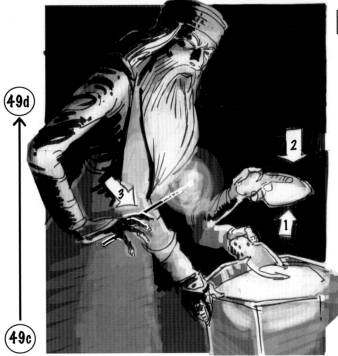

(49d)

(49c)

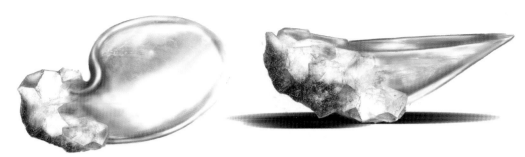

HORCRUX CAVE CRYSTAL GOBLET

"It is your job, Harry, to make sure I keep drinking this potion even if you have to force it down my throat. Understood?"

—Albus Dumbledore, *Harry Potter and the Half-Blood Prince*

One of the first props the designers started on for *Harry Potter and the Half-Blood Prince* was the crystal scoop Harry would use to drain the poisonous water from the basin that held the fake Horcrux locket. "We had originally envisioned a metal cup attached by a chain to the crystal basin for Dumbledore to drink from," says Hattie Storey. "But then we felt that it had to be something that looked as though it could be found in the cave, where there wasn't anything but crystal, and that it would appear semi-manmade. It was obviously found or created on the spot by Lord Voldemort for the purpose of drinking the potion." During her design research, Miraphora Mina came upon an ancient carved jade scoop from China with a sheep's head holder that influenced the organic, crystalline shell-shaped prop. "It was one of those times," Storey concludes, "that once you find the solution, it seems as if it just couldn't have been anything else." However, this was easier said than done. It took sixty prototypes before the final piece was approved to be molded and cast.

OPPOSITE: Storyboard art of the scene adds detail of how the ladle will scoop up the water; ABOVE: Concept art by Miraphora Mina of the crystal goblet used in *Harry Potter and the Half-Blood Prince*; BELOW: Harry Potter helps Albus Dumbledore drink the basin's potion in order to retrieve the Horcrux locket in visual development art by Adam Brockbank.

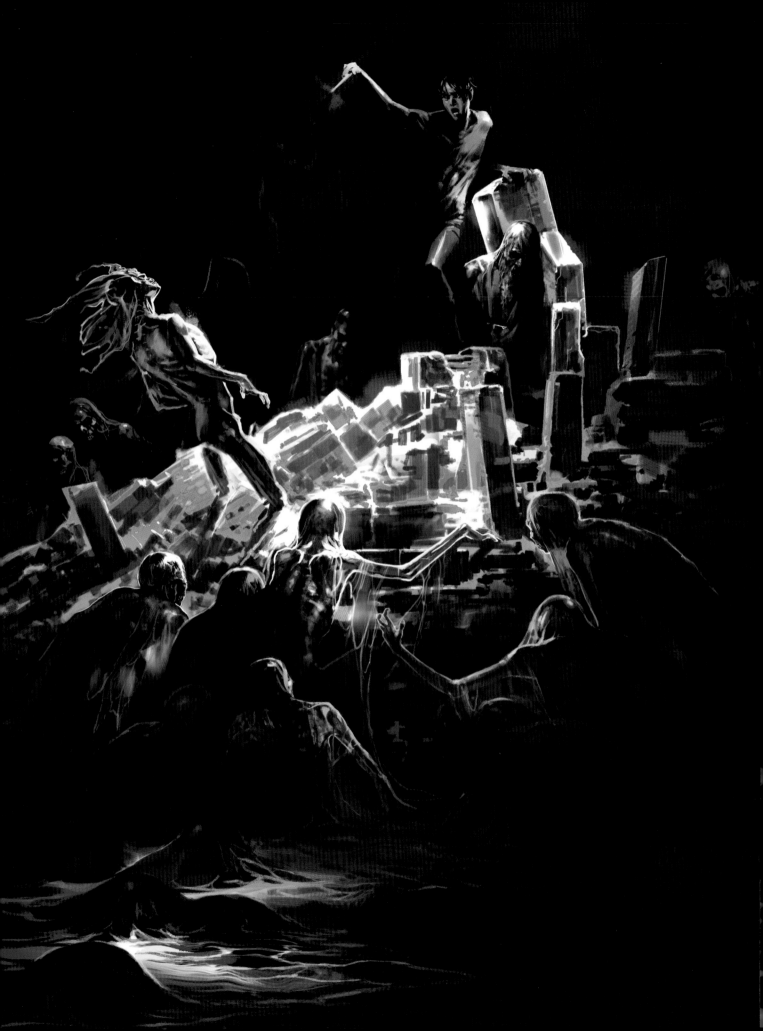

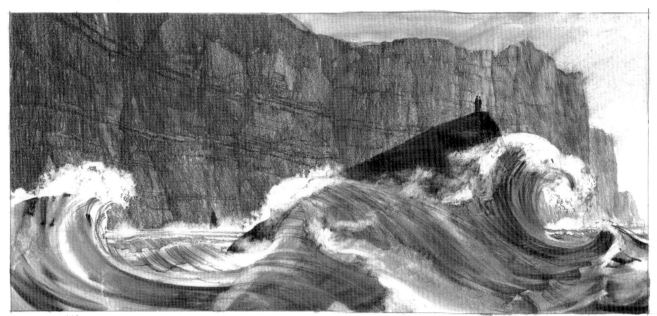

EXT OCEAN, CLIFF & CAVE

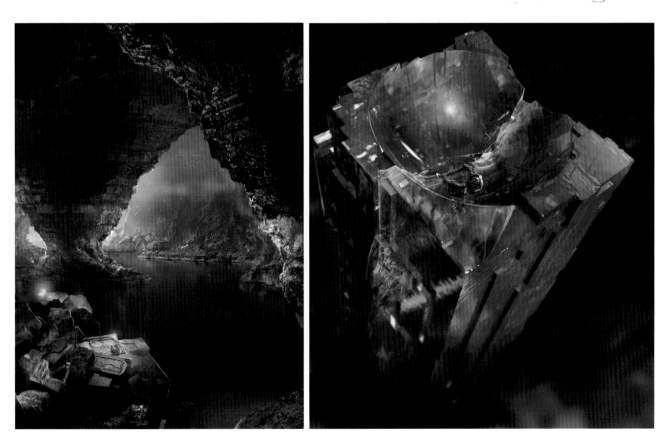

OPPOSITE: Harry fends off Inferi in concept art by Adam Brockbank for *Harry Potter and the Half-Blood Prince*; TOP: Stuart Craig's sketch of the entrance to the Horcrux cave; ABOVE LEFT: A view of the cave interior, artwork by Andrew Williamson; ABOVE RIGHT: Concept art for the crystal basin by Andrew Williamson.

HELGA HUFFLEPUFF'S CUP/
LESTRANGE GRINGOTTS VAULT

"Are you thinking there's a Horcrux in Bellatrix's vault?"

—Hermione Granger, *Harry Potter and the Deathly Hallows – Part 2*

"Any prop, but especially one that has significance to the story, goes through a long design process," explains Pierre Bohanna. "At least half a dozen designs go in front of the director and producers for approval." The Hufflepuff cup is a case in point: Originally presented to be twice its size, the filmmakers asked if it could be made smaller. Did this influence Miraphora Mina's design? "At the time, book seven hadn't come out, so all we knew was that we just needed a badger on it," she explains. "It was meant to be very modest. It didn't have that kind of magisterial thing that the others did. I can't say whether it would have affected the design if we had known that it was going to need to multiply into thousands and thousands!"

Mina's influences included gold goblets and thistle-shaped medieval cups. First, a full-size mold of the design was crafted, with a bas-relief of the Hufflepuff badger upon it. Then the prop makers used a method of metalcraft where, in this case, a thin layer of pewter was beaten onto it. Finally, the pewter was painted gold by Pierre Bohanna. The cup was commissioned for *Harry Potter and the Half-Blood Prince* to be placed in the Room of Requirement, but it wasn't really seen until *Harry Potter and the Deathly Hallows – Part 2*, when Harry, Ron, and Hermione invade Bellatrix Lestrange's vault at Gringotts. Due to a spell on the vault's contents, any object touched will multiply and multiply and multiply. . . . "We used the analogy of a children's ball pit," explains Hattie Storey, "where you have to wade through all those plastic balls. It's a bit like that, but with treasure and gold."

In order to create the amount needed, Pierre Bohanna used an injection-molding machine that needed to run on a twenty-four-hour schedule. "We had six different objects that we made soft rubber copies of," Storey continues, "so in the end we had literally filled twenty cubic meters of that vault." In order to reach the real Horcrux cup at the topmost corner of the vault, Daniel Radcliffe (Harry Potter) leapt upward onto a series of rising platforms hidden beneath the thousands of props. The real cup is destroyed by Hermione Granger in the Chamber of Secrets.

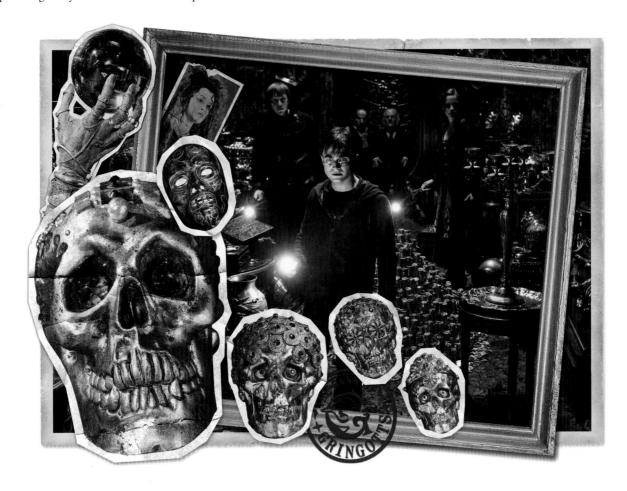

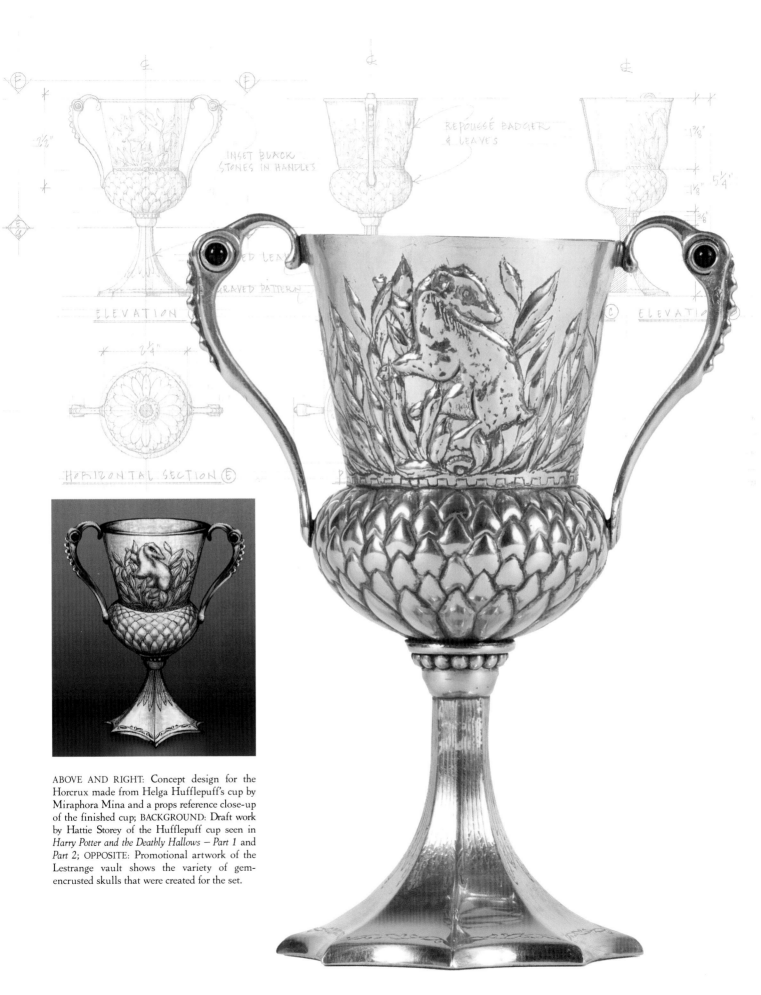

Text visible within the background design drawings:

INSET BLACK
STONES IN HANDLES

REPOUSSÉ BADGER
& LEAVES

...ED LEA...

...RAVED PATTERN

ELEVATION

HORIZONTAL SECTION Ⓔ

ABOVE AND RIGHT: Concept design for the Horcrux made from Helga Hufflepuff's cup by Miraphora Mina and a props reference close-up of the finished cup; BACKGROUND: Draft work by Hattie Storey of the Hufflepuff cup seen in *Harry Potter and the Deathly Hallows — Part 1* and *Part 2*; OPPOSITE: Promotional artwork of the Lestrange vault shows the variety of gem-encrusted skulls that were created for the set.

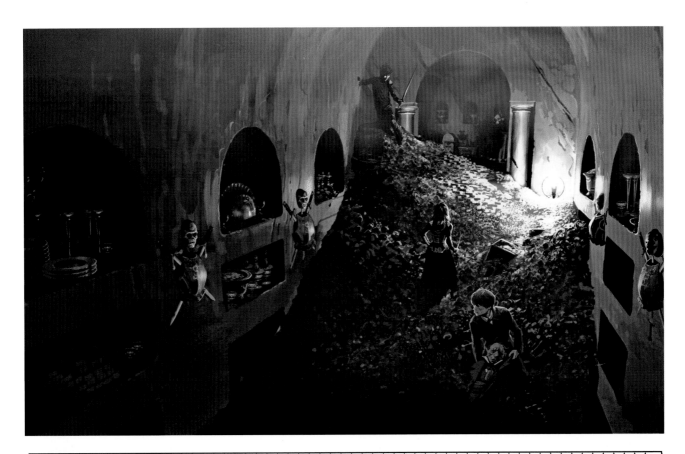

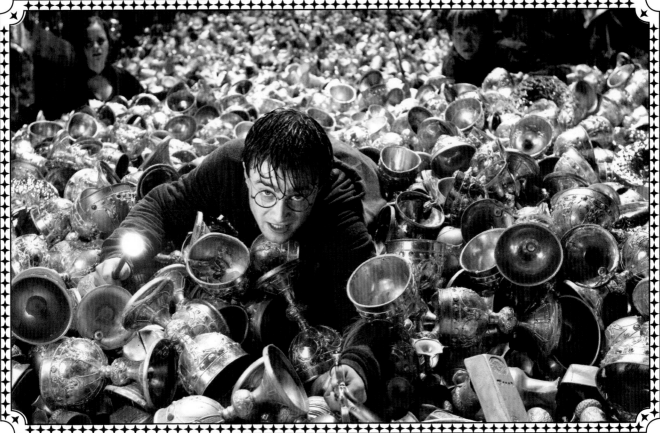

OPPOSITE: Close-up detail of Death Eater armor on the wall of the Lestrange vault; TOP: Harry, Ron, and Hermione are trapped in Bellatrix Lestrange's vault as gold coins and other objects multiply around them in *Harry Potter and the Deathly Hallows – Part 2*, artwork by Adam Brockbank; ABOVE: Harry Potter (Daniel Radcliffe) reaches for the Hufflepuff cup with the Sword of Gryffindor.

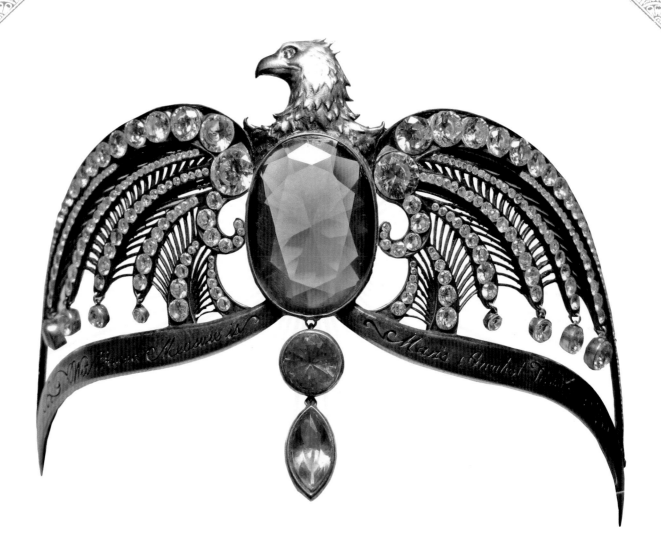

ROWENA RAVENCLAW'S DIADEM

"Excuse me. Could someone tell me what a bloody diadem is?"

—Ron Weasley, *Harry Potter and the Deathly Hallows – Part 2*

The diadem of Hogwarts founder Rowena Ravenclaw also went through several redesigns before its final iteration. "It was scripted to be in *Harry Potter and the Half-Blood Prince*, and we did make one," recalls Hattie Storey, "but it was never seen. Then we redesigned it for *Harry Potter and the Deathly Hallows – Part 2*. Now it's so different I'm glad it wasn't established in the sixth film." There are, as with Salazar Slytherin's locket, actually two versions of the diadem (which Cho Chang informs Ron is *". . . kind of crown. You know, like a tiara"*).

In the book *Harry Potter and the Half-Blood Prince*, Xenophilius Lovegood (a Ravenclaw, as is his daughter, Luna) believes he is in the possession of the diadem. Sharp eyes will spot a double-eagle

tiara resting atop a bust of Rowena Ravenclaw when Harry, Hermione, and Ron visit Lovegood looking for information in *Harry Potter and the Deathly Hallows – Part 1*. But the real Horcrux is at Hogwarts in the Room of Requirement. Clearly, the Ravenclaw diadem needed to include an image of the Ravenclaw eagle. It is a success of design that the diadem is actually shaped by the wings of a singular eagle. The wings are outlined in clear white gems, and the eagle's body and hanging "tail feathers" are made of three multifaceted light blue stones. The diadem is destroyed by Harry with the same Basilisk tooth used to destroy the Hufflepuff cup, and then kicked into a blazing Fiendfyre by Ron.

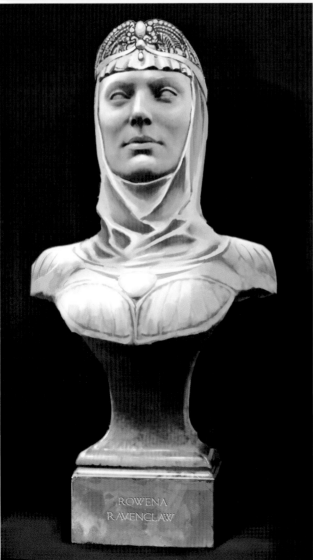

OPPOSITE: Rowena Ravenclaw's diadem incorporates the Ravenclaw house's eagle and her maxim, "Wit beyond measure is man's greatest treasure," inscribed along the bottom of the eagle's wings, in its design; TOP: An early concept of the Ravenclaw diadem painted by Miraphora Mina for *Harry Potter and the Half-Blood Prince*; BELOW: The diadem was created but not used in the movie; LEFT: Concept art by Adam Brockbank of a bust of Rowena Ravenclaw wearing a diadem (similar to but not the real one) seen in the Lovegood house; ABOVE: The fake diadem is fairly easy to spot in a set reference photo for *Harry Potter and the Deathly Hallows — Part 1*.

A

[9]

ANGLE
DOWN TABLE -
COME.
'I'VE SAVED
YOU A SEAT.'

[CUT]

B

C.U.
VOLDEMORT:
'YOU KNOW OUR
HOSTS, OF COURSE
SEVERUS.'
etc. etc
'ARE YOU BURDENED?'

[CUT]

C

ANGLE
ON THE
MALFOYS -

LUCIUS:
'MY LORD?'
NARCISSA:
'IS ALWAYS
WELCOME
HERE.'

[CUT]

I

EX. TOP SHOT
CAM.
SLIDES
TOP TO
BOTTOM -

SEE
SNAPE
MOVING
DOWN
ROOM,
LOOKING
UP AT
THE SLOWLY
REVOLVING
FIGURE
IN F.G.

[CUT]

B

..TO C.U.

'NAGINI'...

C

PULL
BACK
&
TILT
DOWN

'DINNER'..

I

FADE
OUT

END of Sc. 8-12 MALFOY MANOR
[POST CREDIT SEQUENCE..]

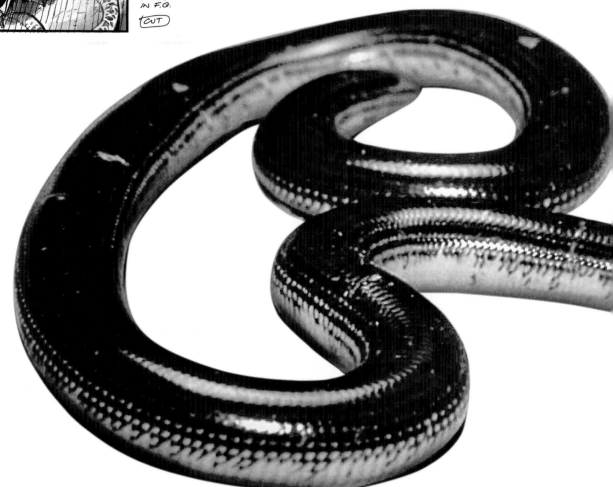

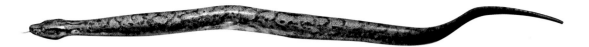

NAGINI

"It's the snake. She's the last one. The last Horcrux."

—Harry Potter, *Harry Potter and the Deathly Hallows – Part 2*

Fearsome and faithful to Lord Voldemort, Nagini is the only fully computer-generated Horcrux. For her first two appearances, in *Harry Potter and the Goblet of Fire* and *Harry Potter and the Order of the Phoenix*, Nagini's design was a fusion of Burmese python and anaconda, both of which come up shorter than this snake's twenty-foot length. Though the intention was always for Nagini to be a digital construct, the creature shop fabricated a fully painted maquette (model) of the snake at her full size, which was then cyberscanned for the computer animators.

Nagini's role was increased in *Harry Potter and the Deathly Hallows – Part 1* and *Part 2*, and it was "very important that we create a very believable, scary character," explains Tim Burke, visual effects supervisor. "Nagini is a servant to Voldemort, but also a very evil creature in her own right. I felt that when we'd last seen her, she wasn't quite a real snake. In the past she never had a large role, but in this film she was going to have a lot of chances to scare the kids." Burke convinced his team that the best inspiration for the revamp would be a real snake, so he brought a professional snake wrangler into Leavesden Studios to let them observe a real python.

In addition to the animators filming and sketching the snake, one of the digital artists created all the textures of Nagini's scales by hand from still shots of the python. This allowed CGI to capture the iridescence and reflective quality of snakeskin as well as truer, more vibrant colors. Viper- and cobralike movements were added for additional creepiness, her eyes were given the depth of a viper's, and her fangs were sharpened.

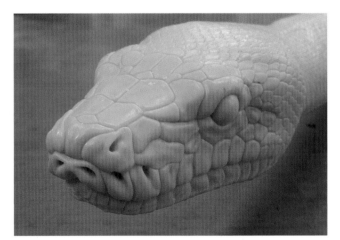

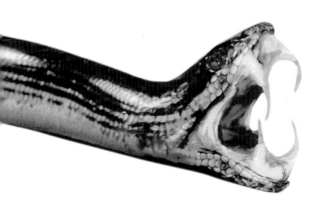

OPPOSITE TOP: Storyboard art for *Harry Potter and the Deathly Hallows – Part 1* of Voldemort offering Nagini a meal (of Professor Charity Burbage); OPPOSITE BOTTOM: Nagini in her python/ anaconda mash-up by visual development artist Paul Catling for *Harry Potter and the Goblet of Fire*; TOP: Nagini was tried with more boa constrictor characteristics in another possibility by Catling; ABOVE LEFT: A full-scale model of Nagini; ABOVE RIGHT: Barty Crouch Jr. (David Tennant) and Nagini watch over the barely corporeal form of Voldemort in *Harry Potter and the Goblet of Fire*.

SWORD OF GRYFFINDOR

"It would take a true Gryffindor
to pull that out of the Hat."

—Albus Dumbledore, *Harry Potter and the Chamber of Secrets*

Any mention of Horcruxes can't go without a nod to the Sword of Gryffindor, which destroys the ring, the locket, and the snake. Harry Potter first encounters the sword in *Harry Potter and the Chamber of Secrets* when he pulls it out of the Sorting Hat and uses it to kill the Basilisk. Goblin-made, the Sword is able to absorb qualities that strengthen it; in this case the serpent's venom, which is one of the few ways to destroy a Horcrux. We see a flashback of Dumbledore using the Sword to destroy the ring Horcrux in *Harry Potter and the Half-Blood Prince*, and then Neville Longbottom also pulls it from the Hat, in *Harry Potter and the Deathly Hallows – Part 2*, and kills Nagini with it. The prop makers purchased a real sword at an auction for reference and researched medieval swords for inspiration. The Sword is set with ruby cabochons, the color of Gryffindor house, and has a small inset picture on the top of its blade, presumably of Godric Gryffindor.

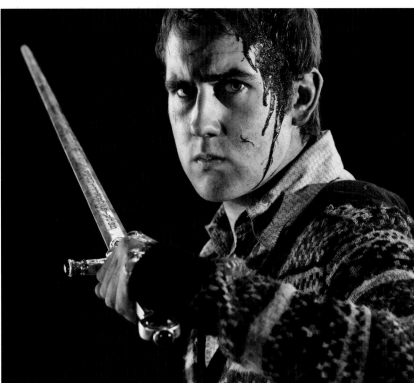

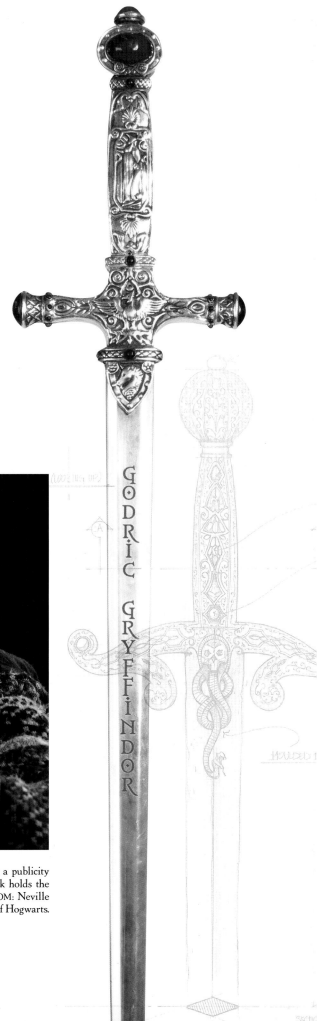

ABOVE: Neville Longbottom (Matthew Lewis) poses with the Sword of Gryffindor in a publicity still; RIGHT: A true "hero" artifact: the Sword of Gryffindor; OPPOSITE TOP: Griphook holds the Sword of Gryffindor prior to the group escaping from Malfoy Manor; OPPOSITE BOTTOM: Neville Longbottom (Matthew Lewis) and Luna Lovegood (Evanna Lynch) rest after the Battle of Hogwarts.

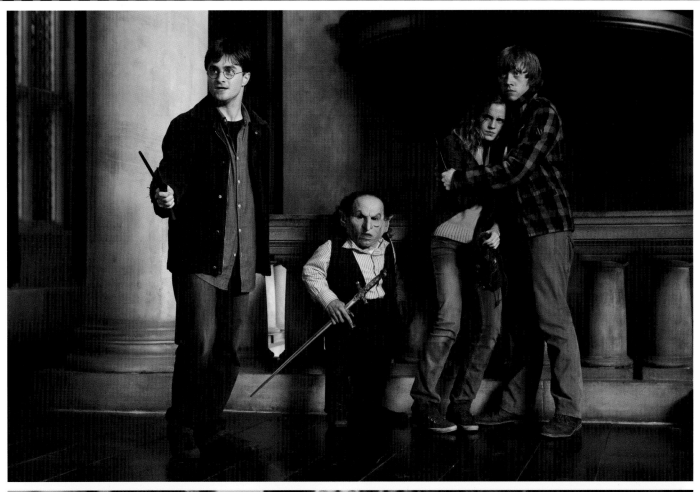

THE DEATHLY HALLOWS

"What do you know about the Deathly Hallows?"
"It is rumored there are three: the Elder Wand, the Cloak of Invisibility that hides you from your enemies, and the Resurrection Stone to bring back loved ones from the dead. Together they make one the Master of Death. But few truly believe that such objects exist ..."

—Harry Potter and Garrick Ollivander, *Harry Potter and the Deathly Hallows – Part 2*

In addition to the Horcruxes, Harry Potter is made aware of three more articles that need to be accounted for: the Deathly Hallows, which will make Lord Voldemort invincible. The discovery of what these are and who possesses them is stunning, as they have been visibly part of the story all along and are associated with Harry, Dumbledore, and the young Voldemort. Harry first learns of the Deathly Hallows when he sees a curious necklace worn by Xenophilius Lovegood at Bill Weasley's wedding in *Harry Potter and the Deathly Hallows – Part 1*. The three artifacts the stylized necklace represents are believed by some to hold the key to becoming the Master of Death. Harry's suspicion is that Lord Voldemort has assumed the legend is true and is making efforts to acquire them. The Dark Lord steals the first—the Elder Wand—from Dumbledore's crypt in the epilogue of *Harry Potter and the Deathly Hallow – Part 1*. Harry unknowingly already possesses one—the Cloak of Invisibility—and inherits the third—the Resurrection Stone—from Dumbledore.

INSET: Development artwork by Miraphora Mina of the necklace Xenophilius Lovegood wears in *Harry Potter and the Deathly Hallows – Part 1*; BELOW: Hermione Granger, Ron Weasley, and Harry Potter watch as Lovegood sketches out the symbol for the Deathly Hallows in a scene from the film; OPPOSITE: Storyboard art of the same scene.

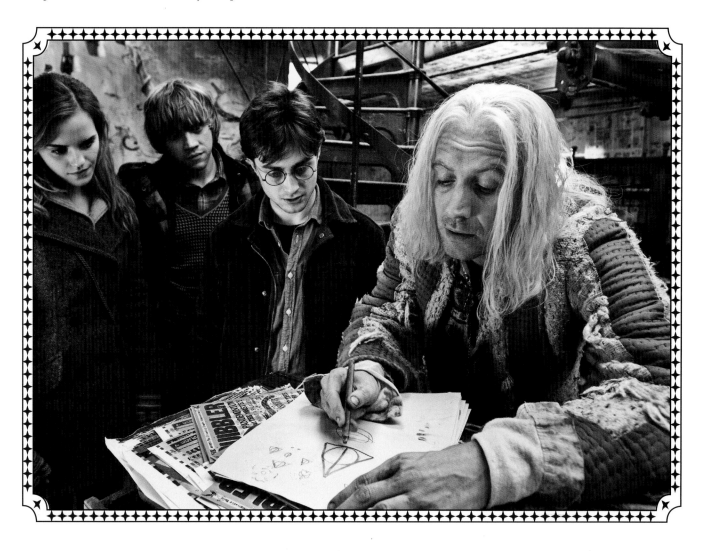

A

Wider as the group try to follow what Lovegood is saying.

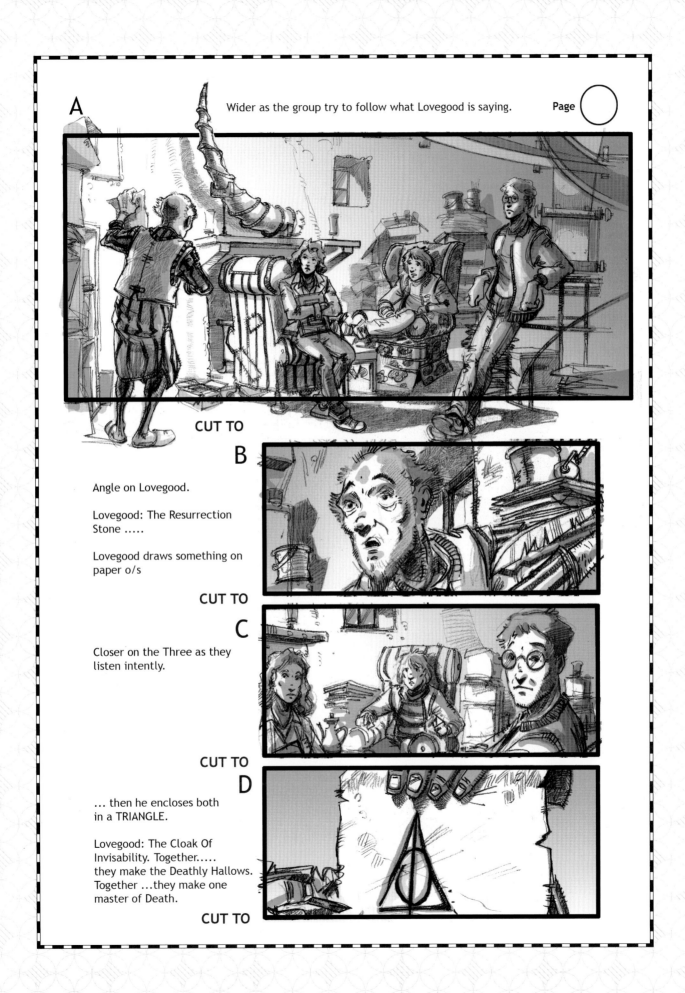

CUT TO

B

Angle on Lovegood.

Lovegood: The Resurrection Stone

Lovegood draws something on paper o/s

CUT TO

C

Closer on the Three as they listen intently.

CUT TO

D

... then he encloses both in a TRIANGLE.

Lovegood: The Cloak Of Invisability. Together..... they make the Deathly Hallows. Together ...they make one master of Death.

CUT TO

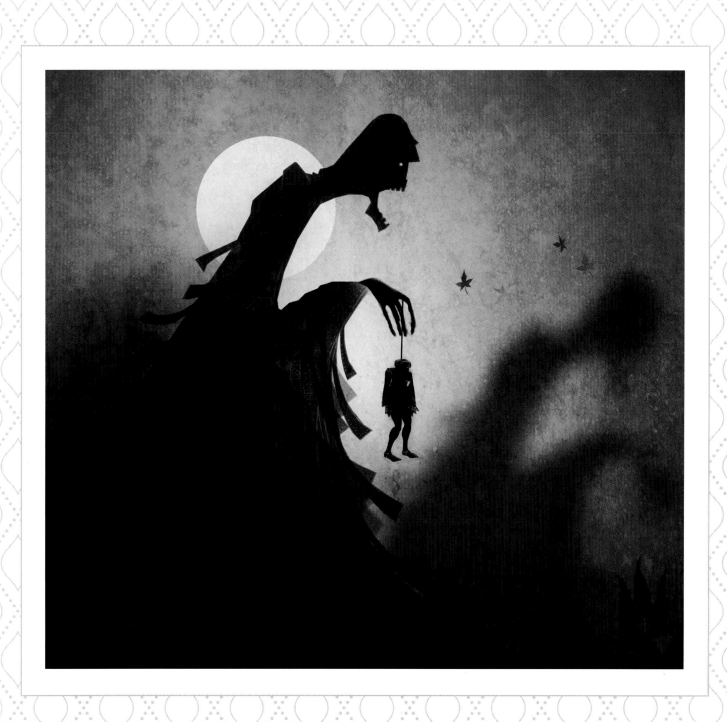

THE TALES OF BEEDLE THE BARD

"To Hermione Jean Granger, I leave my copy of The Tales of Beedle the Bard, in the hope that she finds it entertaining and instructive."

—Rufus Scrimgeour, reading from the Last Will and Testament of Albus Dumbledore, *Harry Potter and the Deathly Hallows – Part 1*

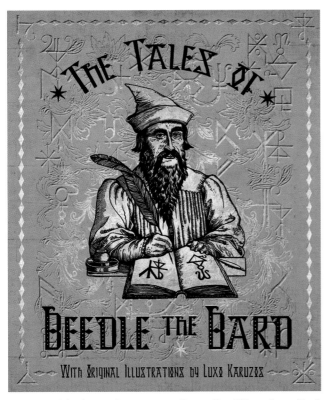

The stories written by Beedle the Bard are the wizarding world's equivalent of fairy tales by the Brothers Grimm or Hans Christian Andersen. It is crucial for Hermione Granger to receive Dumbledore's copy of *The Tales of Beedle the Bard* in order to understand the history and portent of the Deathly Hallows and to become familiar with *The Tale of the Three Brothers*, a story about three wizard brothers whose efforts to outwit death result in the creation of the Hallows—the Elder Wand, the Resurrection Stone, and the Cloak of Invisibility.

Miraphora Mina and Eduardo Lima knew that the design of this book needed to show that though it was a children's book, within it there was more gravity to the stories. The small book contains delicate laser-cut illustrations resembling a fine lace that front each story. The artist of these "original illustrations" is listed as Luxo Karuzos, another variation on Mina's son's name. It was the director's intention to zoom in on the illustration before the Three Brothers tale and through that segue to the animated telling of the story, but this idea was not implemented for the film's final cut.

Throughout their work on the films, Mina and Lima would show key props to the filmmakers, including an unfinished copy of this book, for approval. When J.K. Rowling was on set one day during the shooting of *Harry Potter and the Deathly Hallows – Part 1*, producer David Heyman took her over specifically to show her *The Tales of Beedle the Bard*. "She looked at it and said, 'Oh, I have to have one,'" remembers Lima. "And we said, 'It's not ready yet, you need to wait until we finish the book.' She said okay and gave me back the book. Not two seconds later, she came back and said, 'I'm really sorry, but I need to take one now,' and she gave me a massive big hug. We were like, 'What?' But she's so lovely, we couldn't refuse!"

OPPOSITE: Color key art by animation director Ben Hibon shows Death departing with the second brother; BELOW: "Color key," reference art created for the lighting and animation teams, by sequence supervisor Dale Newton depicts the brothers creating the bridge across the river in the *The Tale of the Three Brothers* sequence in *Harry Potter and the Deathly Hallows – Part 1*; ABOVE: Albus Dumbledore's copy of *The Tales of Beedle the Bard*, bequested to Hermione Granger, provides a vital clue in the pursuit of the Deathly Hallows. Cover design by Miraphora Mina and Eduardo Lima; FOLLOWING PAGES: Pages from *The Tales of Beedle the Bard* prop book.

The Tale
✳ of the ✳
Three Brothers
✳

 ᛗᚱᚨ ᚱᚷᚱᛗ ᚨᚱᚾ ᚱᛗᚾᚱᚷ ᚨᛈᛉᚾᚱᛗ
ᛉᚱᛏᚨ ᛉᚱᛒᚱᛗ ᛉᛏᛉᛈ ᚽᛏᛒᚱᛉ ᚤᚱᛉᚾᛗ ᚷᛏᛈ
ᚾᛉ ᚤᛈᚾᛈᛉᛈ ᛁᛒᛁᚱᚷᚱᛗ ᛁᛏ ᛁᚨ
ᚨᚷ ᚷᛒᚱᚾᚾ ᛁᚾᛁᚱᛒᛒᛈ ᛗᚱᚷ ᚈᛗ ᛁᛏᛉᛈᚨ
ᛁᚱᛗᚽᚾᚾᛁᛏᚷᛗ ᚨᛁᛗᚱ ᚾᛉᛗᚨᚷ ᚨᛁᚨᛒᚾᛉᚱᛗ
ᛉᛁᛗᚨᚱᛒᚱ ᚨᚨᚾᛁᛈᛈᚨ ᚨᚨᛉᛉᚱ

ᚨᛏ ᛁᛁᚨᚷ ᛈᛁᛗᚱ ᚾᚾᛁᛁᛁᛗᚷ ᚱᚷᚱᛗ ᛗᛏᛁᛁᚾᛈᚾᛁ
ᚾᛁ ᛈᛒᛁᛈᚱ ᛁᚱᛗᚾᛁᛁᚾᚱᛗᛗ ᚷᛈᛗᛗ ᚈᛗ ᚨᛏᛁᛈ
ᛁᚱᛗᚾᚾᛁᛁᚷᛁᚾᛁᛈᚷᛗᛗᛗ

ᚷᛈᛗᛗ ᚈᛗ ᚨᛏᛁᛈ ᛁᚱᚾᚾᛁᛏᚷᛁ ᚷᚾᚾᚱᛒᛈ ᚽᛏᛒᚱᚷ
ᚾᛉᛗᚷ ᚨᛏᛁᛈ ᛗᚱᛗ ᛈᚱᚱᛗ ᛈᛈᛁᛗᚱᛗᚱᛗ
ᚨᛈᚾᛉᛈᛗᚾᛁᛈ ᚱᛉᚾᛗ ᛈᛈᚱᛗ ᛁᚱᛉᚾᛗ ᛁᛈᛁᛉ
ᛈᛈᛈᛁᛈᛗᛈᛉ ◇ ᛁᛈᚱᛈᛁᛉᛗ

ᚨᛗᛁᛉᚾᛈᛁᛁᛈ ᚷᛈᛗᛗ ᚈᛗ ᚨᛏᛁᛈ ᛁᚱᛗᚾᚾᛁᛁᚷᛁ
ᛗᛏᛈᛗᛏᛈ ᚷᚾᚾᚱᛒᛈ ᛗᛁᛁᛉᚾᛈᛁᛁᛗ ᛗᚱᚨ
ᛈᛈᚱᛗᚱᛗᚱᛗ ᛈᛈᚾᛉᛈᛗᚾᛁᛈ ᚱᛉᚾᛗ ᛈᛈᚱᛗ ᛁᚱᛉᚾᛗ
ᛁᛈᛁᛉ ᛈᛈᛈᛁᛈᛗᛈᛉ ᛉᛈᛁᛈᛈᚾᛁ ◇ ᛁᛈᚱᛈᛁᛉᛗ
ᛁᚱᛗᚾᚾᛁᛁᚷᛁ ᚷᚾᚾᚱᛒᛈ ᛁᛁᚾᛗ

✤✳✤

THE TALE OF THE THREE BROTHERS

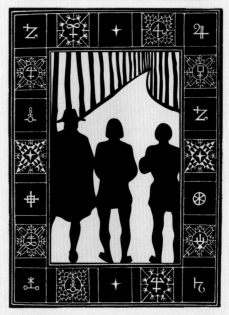

There were once three brothers who were
traveling along a lonely, winding road at twilight

The Wizard
✳ and the ✳
Hopping Pot
✳

 ᒪᵒ⚥ᛏᛐᛩ ᚥᵒᒪᛏᛩ � ⚹ᛐᚥᛐᚋ
ᚥᵒᛏᛐᛘ ᚥᛐᛐᛩᛐᛩ ᚥᛐᚥᒪᛐᛩᛩ ᛩᛐᚥᛁᒪᵒ
⚹ᛐᚋᛐᛩ ᛐᛐᛏᵒᛁᛩ ᛐᛩ ᚥᛐᛩᵒᚥᛩᛩᛩ
⚥ᛐᛁᵒᚥ ᛐᚋᵒᛐᛐ ᒪᵒᛩᛩ △ᵒ⚥ᛩᵒᛩ ⊙ᛏᛐᚋ ᛐᒪᒪᛏᛐᛩᛐᚋ ⚸
ᚋᛐᛐᒪᒪᛐᚋᵒᛩ ⚹ᛐᚥᛩᛐᚥᛐᛏᚋ ᚥᛐᚥᒪᛐᛩᛩ
⊙ᛏᛐᛩᛩ ᛩᛐᚋᛘ ᛐᚋᛁᛐᛩ ⚹ᛏᛐᛩᛩ ᛐᚥᛐᛩᛐᚋ
⚹ᛏᛐᛩᛐᛩᛏᛩ ⊙ᛩᚋᛏᛐᛩᵒ ⊙ᛏᛐᛩ

⊙ᛏᛐᛩᛩ ᚋᛏᛏᛩᒪ ᚥᛏᛐᛐᚋ ᚋᛐᛩᛩᚥ ᚋᛏᛩᚥ
⚹ᚥᛊᛩᛩᵒᛩ ᛐᛘ ᚥᛐᒪᚋᛩᵒ ᚋᛏᚋ ᛩᛐᚥᛐᛩ

ᚋᛏᚋᛏᛐᛩᛏ ᛩᛐᚋ ᛐᛩ ᚋᛏᛐᚥᚥᵒ ᚋᛐᚥᛩ⚘
ᚥᛐᚥᛏᛐᚋᛩ ᛐᚋᚥᛐ ᛩᵒᛩᛏᚋ ᛐᛐᛩᚋᛏᛩᛩ
△ᛐᛏᒪᛐᚥᛏ ᚥᛐᚋᒪᛩ ᛐᛏᒪᛩᛩᛩ ᛐᛩ
ᛏᛐᚥᛩᵒᒪᛐᛩ ᛐᛩᛩᛏᛐᛁᛩ ᒪᛏᚥᛩᛐᛐᛐᛩ
ᒪᛏᛩᛐᛩ

ᛏᛩ ⊙ᛏᛐᚋ ᛐᚋᛩᛩᛩ ᚥᛩᚥᛁᛐᛐᛩᛏᛁᚋ ᛩᛐᚋᛩ
ᛩᚋᚥᛩᛩᵒᛩᛐᛁᛩ ᛐᛘ ᚋᵒᚋᛐᛐᛁᛩ ᚋᛐᛩ ᚥᛐᚥᒪᛐᛩᛩ
ᚥᛏᛐᛐᚋ ᛩᵒᛏᛏᛩ ⚹ᛐᚥᛐᛩᵒ ᛩᛩ ᛐᚋᛩᛩ

✠✤✠

THE WIZARD AND THE HOPPING POT

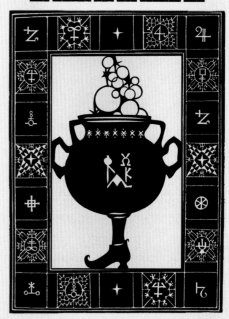

Rather than reveal the true source of his power, he pretended
that his potions, charms and antidotes sprang from the
little cauldron he called his lucky cooking pot.

High on a hill in an enchanted garden, enclosed by tall walls and protected by strong magic, flowed the Fountain of Fair Fortune

The King caused proclamations to be read in every village and town across the land.

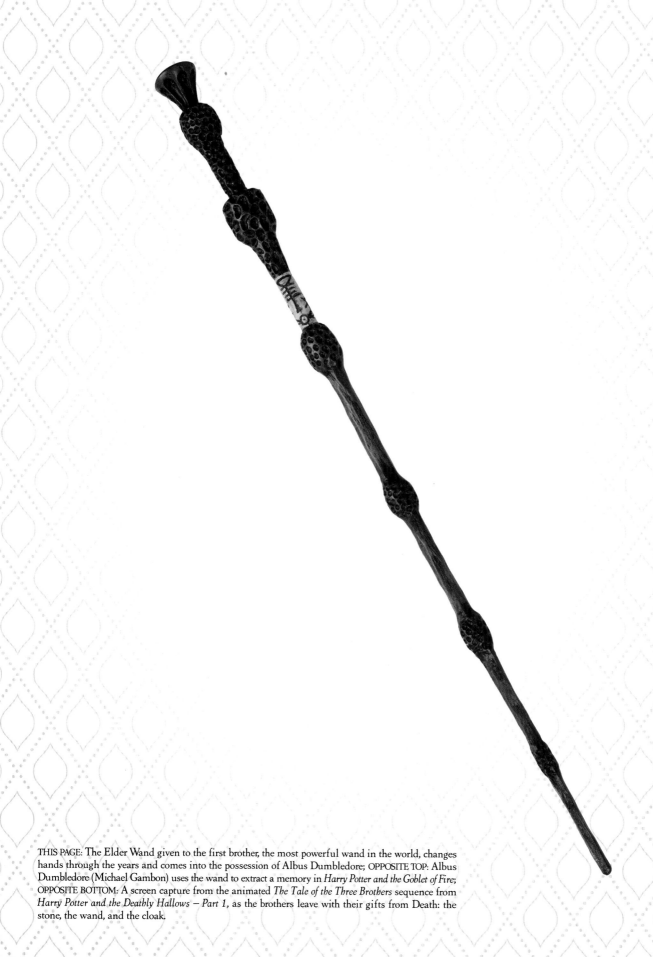

THIS PAGE: The Elder Wand given to the first brother, the most powerful wand in the world, changes hands through the years and comes into the possession of Albus Dumbledore; OPPOSITE TOP: Albus Dumbledore (Michael Gambon) uses the wand to extract a memory in *Harry Potter and the Goblet of Fire*; OPPOSITE BOTTOM: A screen capture from the animated *The Tale of the Three Brothers* sequence from *Harry Potter and the Deathly Hallows – Part 1*, as the brothers leave with their gifts from Death: the stone, the wand, and the cloak.

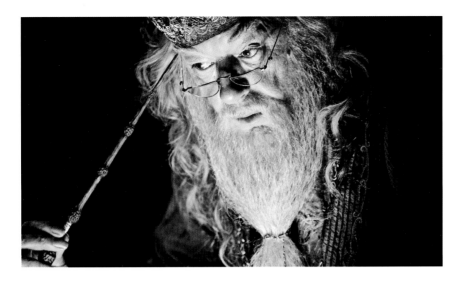

ELDER WAND

"The oldest asked for a wand more powerful than any in existence.
So Death fashioned one from an elder tree that stood nearby."

—Hermione Granger, reading from *The Tales of Beedle the Bard, Harry Potter and the Deathly Hallows – Part 1*

The first samples of wands shown to author J.K. Rowling for *Harry Potter and the Sorcerer's Stone* were crafted in myriad styles, from a gilded Baroque design, to one with roots that had crystals tied on the end, to simple, straightforward, turned wood wands. The latter were the ones Rowling chose. The prop makers produced them in the wood of the wand if they had been mentioned in the book, or if not, in a high-quality wood. "We tried to find interesting pieces of precious woods," Pierre Bohanna explains, "but we didn't want a plain silhouette, so we chose wood that might have burrs or knots or interesting textures to create a unique shape to it." Once the wand was approved, it was molded in resin or urethane, as wood would have broken too easily during use.

The Elder Wand benefitted from this philosophy of shape. Albus Dumbledore's wand was fashioned from English oak and inlaid with a bone-looking material inscribed with runes. "What makes it very recognizable," says Bohanna, "is that not only is it one of the thinnest wands, it has these wonderful outcroppings of nodules on it, every two or three inches." The prop makers had no idea that Dumbledore's wand would turn out to be one of the Deathly Hallows and perhaps the most powerful wand ever. "It's easy to recognize from a distance," Bohanna explains. "And should be, as obviously it's the biggest gun on the set, so to speak. As far as wands are concerned, it's the one to beat all others."

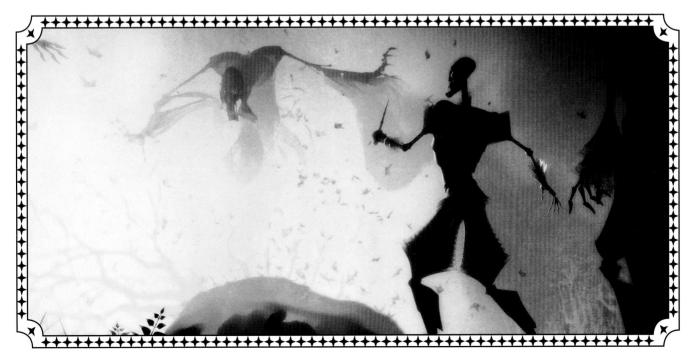

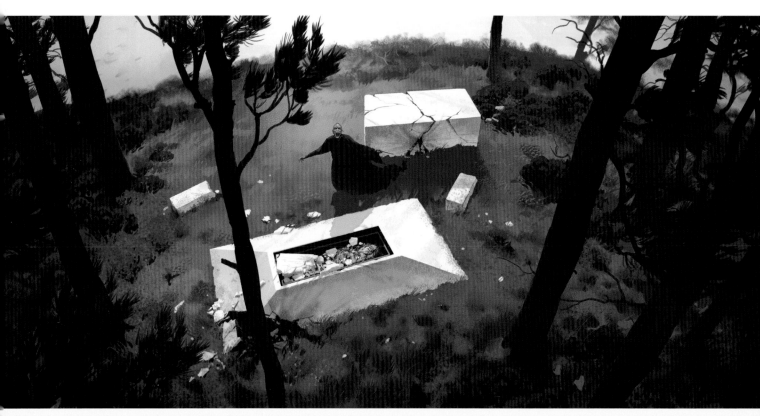

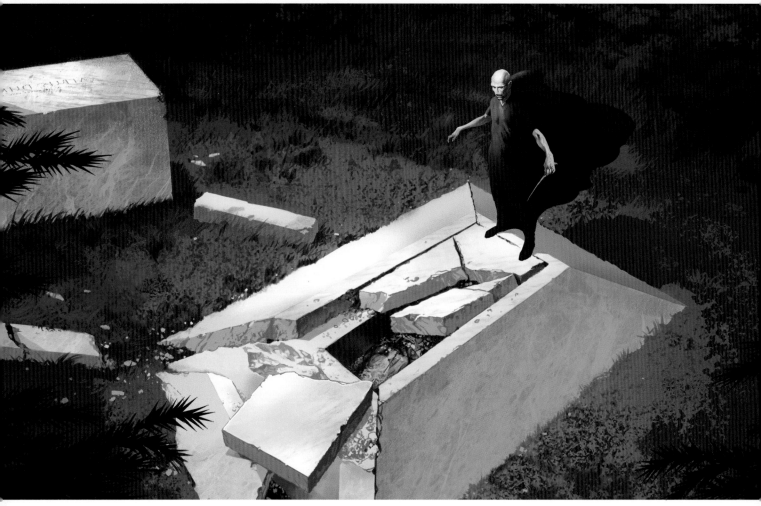

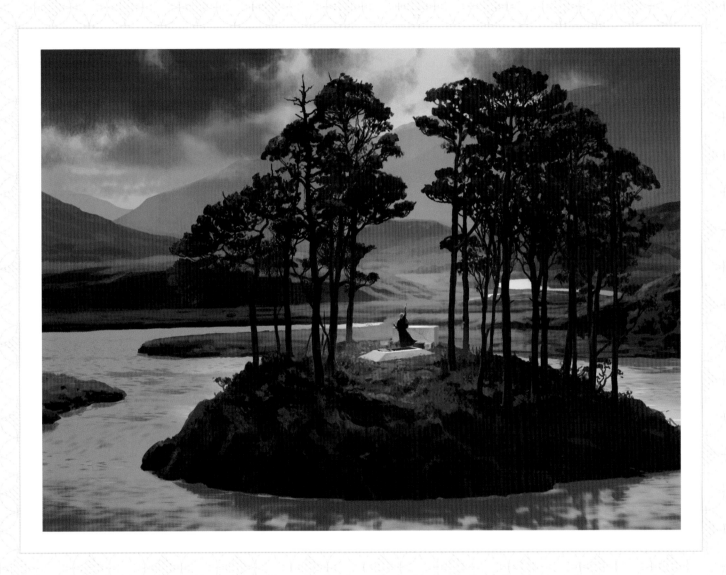

THESE PAGES: Concept art by Adam Brockbank for *Harry Potter and the Deathly Hallows – Part 1* depicts Voldemort removing the Elder Wand from Dumbledore's grave.

INVISIBILITY CLOAK

"Finally Death turned to the third brother. A humble man, he asked for something that would allow him to go forth from that place without being followed. And so it was that Death reluctantly handed over his own Cloak of Invisibility."

—Hermione Granger, reading from *The Tales of Beedle the Bard*, *Harry Potter and the Deathly Hallows – Part 1*

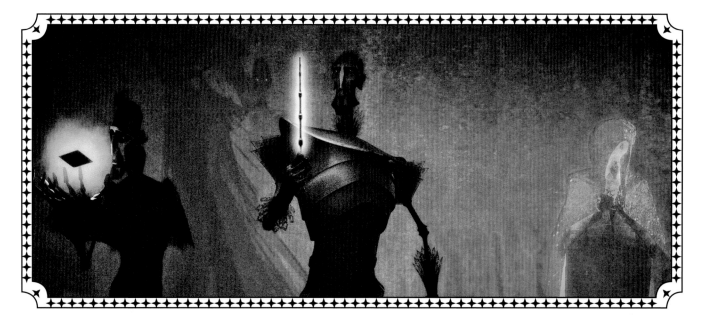

Harry Potter receives an Invisibility Cloak in *Harry Potter and the Sorcerer's Stone* at Christmas, the first holiday at which he has ever received worthwhile presents. A mysterious note accompanies the package informing him that his father, James Potter, left the cloak in the possession of the gift-giver, but it is time it was returned to Harry. Harry uses the cloak throughout the film series (with the exception of *Harry Potter and the Order of the Phoenix*), but it isn't until *Harry Potter and the Deathly Hallows – Part 2* that he discovers its origin and the consequence of it being part of the Deathly Hallows.

The cloak was created by the costume department, under the direction of Judianna Makovsky. The thick velvet material was dyed and imprinted with Celtic, runic, and astrological symbols. Several cloaks were created with this fabric for different uses. When Daniel Radcliffe (Harry Potter) puts on the cloak to make himself invisible, it is a version lined with green-screen material. Radcliffe would subtly flip the cloak around before placing it over him so that the green fabric would be right side up. Another version, lined with the same dyed material on both sides, was used when it would be held or used over a full-body green-screen suit for complete invisibility.

ABOVE: A screen capture from *Harry Potter and the Deathly Hallows – Part 1*. The brothers have received their gifts from Death, who awaits his opportunity to take them back; RIGHT: Color key art by Dale Newton of Death, who cuts a piece of his own covering to make the cloak; OPPOSITE TOP: Harry Potter holds up the Invisibility Cloak, a Christmas present from Albus Dumbledore, in a scene from *Harry Potter and the Sorcerer's Stone*; OPPOSITE BOTTOM: Production shot of Daniel Radcliffe with the cloak flipped to its green-screen side.

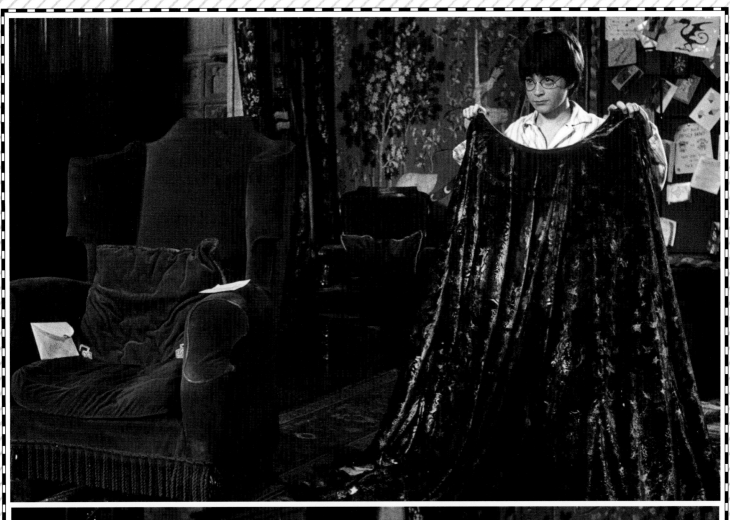

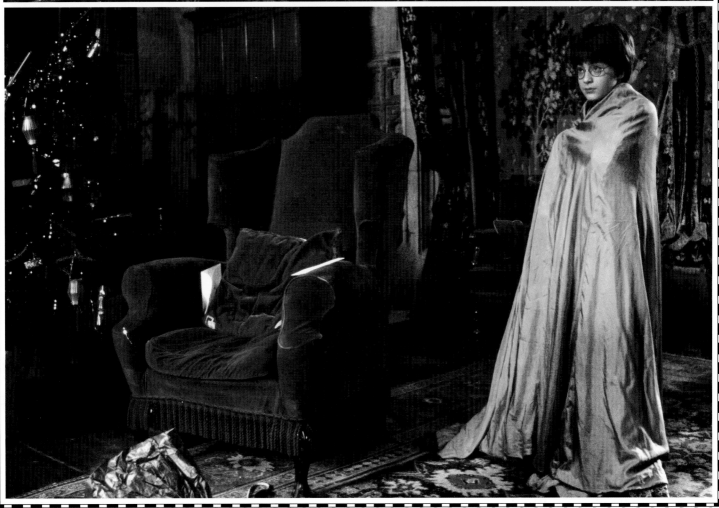

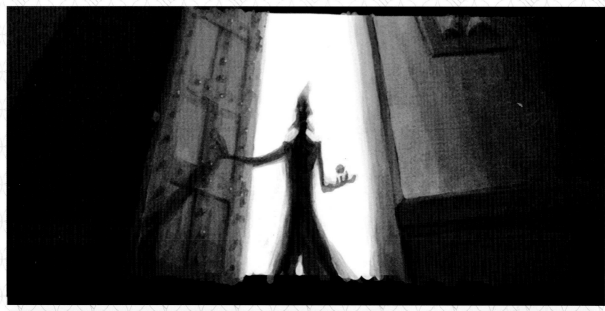

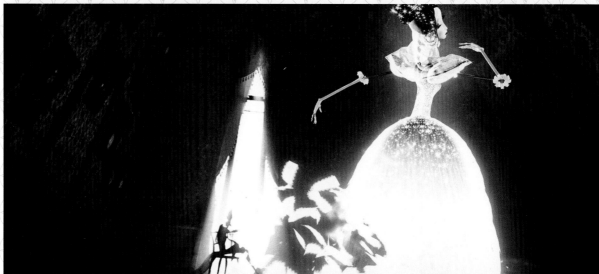

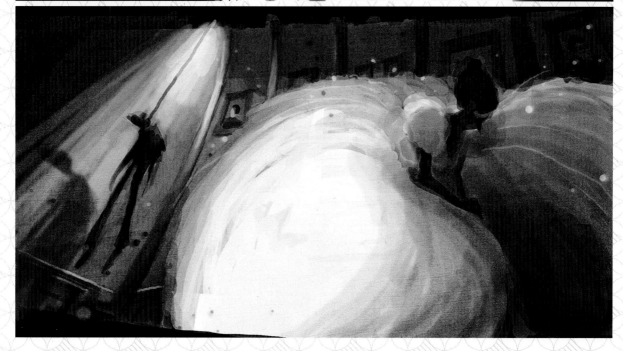

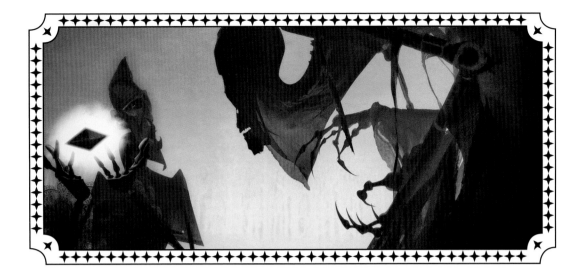

RESURRECTION STONE

"The second brother decided he wanted to humiliate Death even further and asked for the power to recall loved ones from the grave. So Death plucked a stone from the river and offered it to him."

—Hermione Granger, reading from *The Tales of Beedle the Bard, Harry Potter and the Deathly Hallows – Part 1*

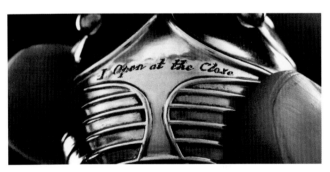

OPPOSITE: Visual development artwork for the animated *The Tale of the Three Brothers* sequence from *Harry Potter and the Deathly Hallows — Part 1*; TOP: A screen capture of the second brother receiving the Stone from Death in *Harry Potter and the Deathly Hallows — Part 1*; ABOVE: The inscription on the Golden Snitch is finally understood by Harry Potter near the end of the events in *Harry Potter and the Deathly Hallows — Part 2*. When the Snitch does open, it reveals the Resurrection Stone, which Harry uses to speak to loved ones who have passed away: his parents, James and Lily; his godfather, Sirius Black; and his teacher, Remus Lupin; BELOW: Visual development art imagines the mechanism used to open the Golden Snitch.

The Resurrection Stone is the only artifact that is both a Deathly Hallow and a Horcrux. The Stone is first seen in *Harry Potter and the Half-Blood Prince* in a cracked, ruined form, having been destroyed as a Horcrux with the Sword of Gryffindor by Albus Dumbledore, at the eventual cost of his own life. The Stone returns in *Harry Potter and the Deathly Hallows – Part 2*, when it is discovered to be inside Dumbledore's bequest to Harry: the first Golden Snitch he ever caught.

The Stone is another example of the filmmakers starting to create a prop for one film before the book that would become the next film was published and the full significance of the prop was known. "We were as much in the dark as everyone else when we first started designing the Stone for the ring Dumbledore had in the sixth film," recalls Hattie Storey. Not only did they not know that it would turn out to be the Resurrection Stone, they didn't know what the symbolic design for the Deathly Hallows was, which needed to be etched onto the Stone. But then, fortunately, the seventh book, *Harry Potter and the Deathly Hallows – Part 1*, came out. "I read through it in a real hurry at first," Storey continues, "and what we learned changed our ideas for the Stone."

The Stone is seen for the last time in *Harry Potter and the Deathly Hallows – Part 2* when Harry touches the Golden Snitch to his lips. It does, as it says, "*. . . open at the close.*" A practical mechanism moves one curve of the Golden Snitch inside another curve at the same time as it pushes the Stone upward, which then becomes its digital double to float in the air.

INSIGHT
EDITIONS

PO Box 3088
San Rafael, CA 94912
www.insighteditions.com

Find us on Facebook: www.facebook.com/InsightEditions
Follow us on Twitter: @insighteditions

Library of Congress Cataloging-in-Publication Data available.

ISBN: 978-1-68383-748-0

Publisher: Raoul Goff
Associate Publisher: Vanessa Lopez
Creative Director: Chrissy Kwasnik
Designer: Judy Wiatrek Trum
Editor: Greg Solano
Editorial Assistant: Jeric Llanes
Senior Production Editor: Rachel Anderson
Senior Production Manager: Greg Steffen

Written by Jody Revenson

 REPLANTED PAPER

Insight Editions, in association with Roots of Peace, will plant two trees for each tree used in the manufacturing of this book. Roots of Peace is an internationally renowned humanitarian organization dedicated to eradicating land mines worldwide and converting war-torn lands into productive farms and wildlife habitats. Roots of Peace will plant two million fruit and nut trees in Afghanistan and provide farmers there with the skills and support necessary for sustainable land use.

Manufactured in China by Insight Editions

10 9 8 7 6 5 4 3 2 1

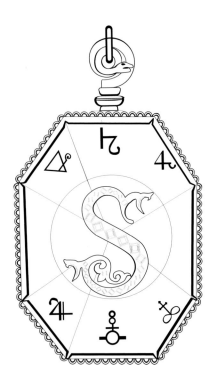